POSTCARD HISTORY SERIES

Portsmouth

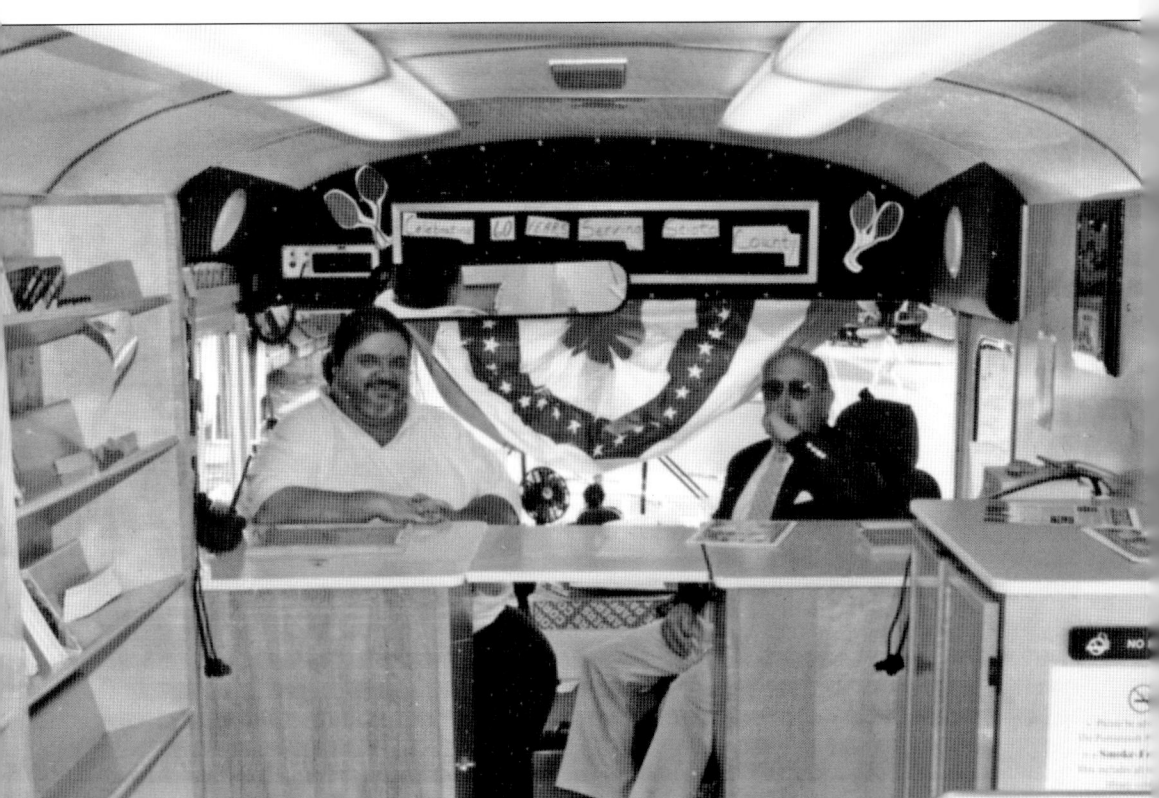

The bookmobile was established in 1938 for rural residents who did not have access to the main library. Originally focusing on schools, in later years the bookmobile also visited high-rise apartments for the elderly, parks, and other town destinations. Henry Clark, the original driver, performed that role for only a few months. Paul Long (right) spent the next 49 years as driver, followed by Tim Jennings (left) for 12 years. (Courtesy Linda Arthur Jennings collection.)

FRONT COVER Perhaps the most recognizable view of Portsmouth, Ohio, is presented in this postcard, looking from the Kentucky hills at the Ulysses S. Grant Bridge, the Ohio River, and downtown Portsmouth. The legendary bridge, completed in 1927, served the area for nearly 75 years before closing in July 2001. Today, another Ohio River bridge with the same name occupies this location. (Courtesy Bill Glockner collection.)

BACK COVER: The Roaring Twenties was a time of economic boom for the Portsmouth area, as shown in this view of Chillicothe Street. The city saw unprecedented population growth, reaching 30,000 residents. New businesses were likewise opening and existing ones expanding, including the railroads and brick and shoe factories. To meet the demand, downtown shops were allowed to open on Sundays for the first time. (Courtesy Linda Arthur Jennings collection.)

Postcard History Series

Portsmouth

Jim Detty, David E. Huffman, and Linda Arthur Jennings

ARCADIA
PUBLISHING

Copyright © 2013 by Jim Detty, David E. Huffman, and Linda Arthur Jennings
ISBN 978-1-4671-1083-9

Published by Arcadia Publishing
Charleston, South Carolina

Printed in the United States of America

Library of Congress Control Number: 2013936886

For all general information contact Arcadia Publishing at:
Telephone 843-853-2070
Fax 843-853-0044
E-mail sales@arcadiapublishing.com
For customer service and orders:
Toll-Free 1-888-313-2665

Visit us on the Internet at www.arcadiapublishing.com

*Dedicated to the memory of Timothy Scott Jennings (1955–2012).
His love for Portsmouth will be preserved
with the sharing of his personal postcard collection.*

Contents

Acknowledgments 6

Introduction 7

1. Industry 9
2. Health Care 17
3. Transportation 23
4. Government and Public Service 35
5. Education 41
6. Floods 55
7. Churches 61
8. Entertainment and Recreation 75
9. Around the Town 89

Acknowledgments

This book would not have been possible without the foresight of those who took the time to preserve our local history. Although they have passed on, their legacy and inspiration will remain forever through their books and in the images they created and collected. Thank you to Carl Ackerman, Nelson Evans, Bill Glockner, Henry Lorberg, and Elmer Swords.

We would also like to express our appreciation to the following for their help and patience during the making of this book: our families, the Local History Department of the Portsmouth Public Library, Elizabeth Blevins, Joe Hannah, Pastor Gary Heimbach, Janet Humble, Chris Lewallen, Andy Lyles, Craig Shaw, and Karen Sue Wikoff. Words of gratitude are also given to Jill Nunn and Mary Margaret Schley of Arcadia Publishing, who very patiently worked with three first-time authors in compiling this book.

Special appreciation is given to Paul O'Neill, who so kindly and generously provided access to many rare postcards from his vast collection.

Finally, we would like to thank you, the reader. By reading this publication, you are proof that there are many people who enjoy learning, studying, preserving, or just remembering the history of this area. It is our hope that some may use this knowledge to help make Portsmouth, our home, a better place to live and work for future generations.

Every effort has been made to ensure that this book is as historically accurate as possible. Unless otherwise noted, all images are from the collections of the authors.

INTRODUCTION

"Welcome to Portsmouth, Ohio, Where Southern Hospitality Begins" is the motto of Portsmouth. Located in southern Ohio, on the northern banks of the Ohio River and east of the Scioto River, it is the midway point between four major cities: Columbus, Cincinnati, Charleston, and Lexington. Portsmouth is proud of its beautiful hills, which come alive with the changing of the seasons.

Portsmouth has a population of 20,226 and is the county seat for Scioto County. According to popular belief, the town was named after Portsmouth, New Hampshire, by Capt. Josiah Shackford. He intended to purchase land to lay out a town on the current Portsmouth site, but found it had already been purchased. He suggested to Henry Massie, one of the five owners of the land, that he should start a town there. Massie convinced the others to sell their land to him and filed the plat of Portsmouth in 1803. The plat reflected Massie's vision of the future, but in actuality, the land was swampy and covered with thick woods.

The "Mound Builders" were the earliest-known inhabitants of what is now Portsmouth. These craftsmen made beautiful objects from metal, shell, bone, and stone, and constructed numerous and elaborate temple mound structures, such as the one that remains in Mound Park.

The Wyandot Indians, arriving around 1650, gave the name O-he-uh (Ohio), meaning big or beautiful river, to the river dividing what would become Ohio and Kentucky. They were farmers who grew corn and several varieties of beans, squashes, and sunflowers for oil. The tribe was eventually relocated to an Oklahoma reservation.

In 1745, the Shawnee Indians displaced the Wyandots. They were proud, warlike, and hostile toward the white settlers coming into the area. They named the Ohio River Kiskepila Sepe, which translates to Eagle River, due to the large number of bald eagles found along the river. Shawnee State Park, named after these fierce warriors, is located in Shawnee Forest, what was once their hunting grounds. The forest is one of the most picturesque sights in the region.

Portsmouth's roots began in the 1790s, when a small town just west of Portsmouth, named Alexandria, was founded. After years of flooding by the Ohio and Scioto Rivers, Alexandria was moved to the present-day site of Portsmouth. It was incorporated as a city in 1815.

With early industrial growth, construction of the Norfolk & Western Railway, the Baltimore & Ohio Railroad, and the completion of the Ohio and Erie Canal, Portsmouth quickly became one of the leading cities between Cincinnati and Pittsburgh. In 1916, it had become the largest manufacturer of paving and fire brick in the United States, was home to the world's largest shoestring plant, and was the fourth-largest shoe manufacturing center in the country. The expanding steel industry employed over 1,000 people.

Boneyfiddle, located in Portsmouth's west end, was once a hub of activity, with farmers bringing their crops to town to sell. It also boasted many fine hotels and restaurants. As Chillicothe Street expanded with the establishment of new stores, it became the new center of activity. It was renamed Main Street for a short time, but was changed back to Chillicothe Street when the new name was rejected. As Portsmouth continued to grow, downtown was the place to be. Chain stores such as Sears, J.C. Penny, Montgomery Ward, Kresge, and locally owned stores such as Martings, Bragdons, and Atlas Fashions were always packed. Over time, changing economic conditions led to the closing of these stores, but they still exist in pictures and, more important, in the memories of citizens. Coming full circle, businesses are returning to the Boneyfiddle district. The beautiful and historic buildings are being renewed and getting a new lease on life.

The Underground Railroad played an important role in Portsmouth's history. Runaway slaves, sheltered by area residents who opposed slavery, were provided with food and clothing before continuing on their northern route through Detroit and eventually to Canada. Some of the buildings involved in hiding slaves from their pursuers, such as the former Candyland store at the corner of Second and Market Streets, still remain.

Portsmouth has seen its share of floods, most notably those of 1884, 1913, and 1937. The US Army Corps of Engineers constructed a floodwall to protect the city after the 1937 event. The wall was put to the test with the 1964 and 1997 floods, but passed with flying colors. Frank Gerlach, Portsmouth's mayor in 1992, implemented a new way of honoring local natives by placing a star on the floodwall facing the Ohio River with their name. Known as the Portsmouth Wall of Fame, its more than 100 signatures include such honorees as Al Oliver and Don Gullett.

The Portsmouth Spartans called Portsmouth home from 1929 to 1933 and joined the National Football League in 1930. The team made history when it competed against the Brooklyn Dodgers in one of the first professional football night games. Even though the Spartans had successful years, they could not survive the Depression and the fact that Portsmouth was the second-smallest city in the NFL. The team was sold in 1934 and became the Detroit Lions. In the 1920s and 1930s, Portsmouth had several semi-pro football teams. One of the more popular was the Portsmouth Shoe-Steels, which had Jim Thorpe as a player and coach.

Among Portsmouth's tourist attractions are the murals painted on the floodwall. Artist Robert Dafford and assistant Herb Roe were commissioned in 1993 by a nonprofit group to paint the murals. The group, headed by Dr. Louis Chaboudy, chose scenes depicting Portsmouth's history, starting with the ancient mound builders.

Some of Portsmouth's and the surrounding area's more notable residents include Shakespearean actress Julia Marlowe, opera singer Kathleen Battle, singer and cowboy movie star Roy Rogers, country music singer Earl Thomas Conley, and award-winning Appalachian musician Steve Free. Local men who made a name for themselves in politics are congressman Bill Harsha, Ohio governor Ted Strickland, and Ohio speaker of the house Vern Riffe. Baseball legends Al Bridwell, Al Oliver, Gene Tenace, Josh Newman, Larry Hisle, and Rocky Nelson, to name a few, have all played in the major leagues. Branch Rickey, the baseball executive who broke the color barrier when he signed Jackie Robinson to the Brooklyn Dodgers, is also from the area.

One

INDUSTRY

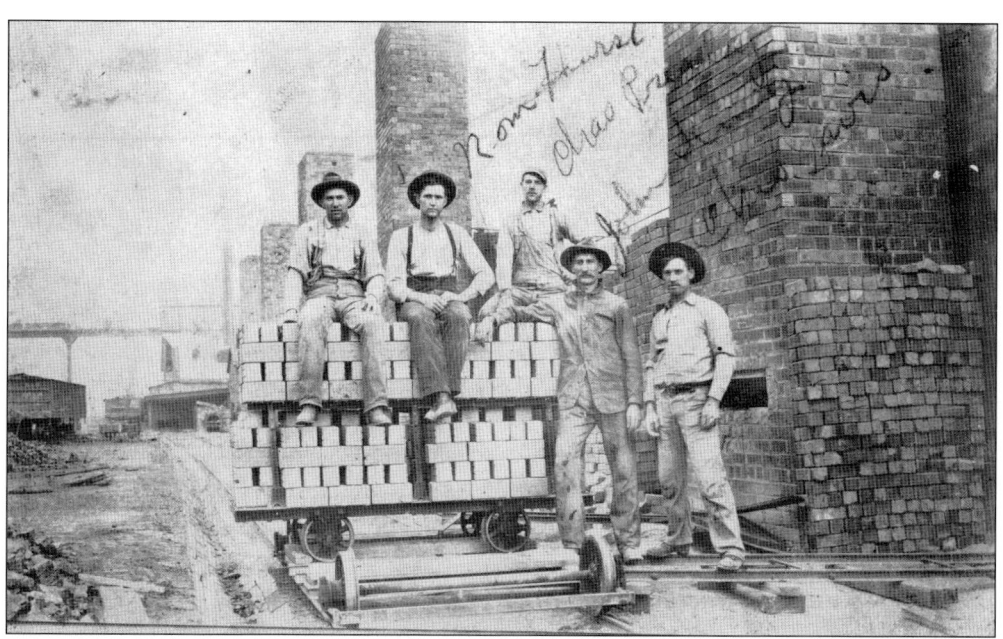

The Carlyle Paving Brick Company was organized in February 1905, with George Carlyle as president and general manager. The company's connections extended to all states east of the Mississippi River. Located in Sciotoville, the 100 employees made an average of 10 million bricks per year. The names Ron Hurst, Chas Presley, and Jon and Chas Davis are written on the photograph shown here. (Courtesy Paul O'Neill collection.)

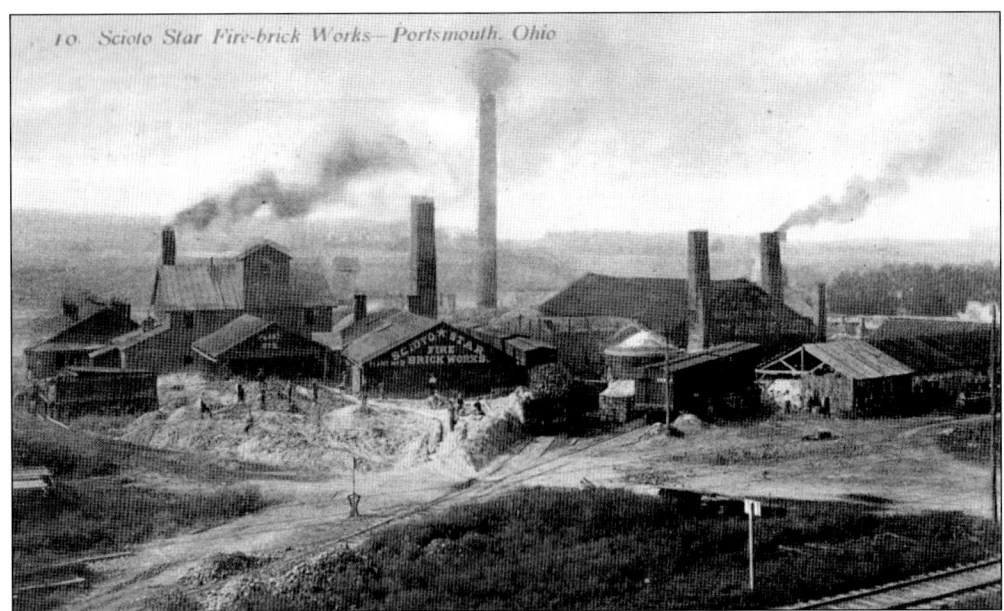

The Scioto Star Firebrick Company opened for business in 1868 and was located one mile west of Sciotoville. One of several brick-making facilities in the area, it operated three separate plants on the property, each one producing a different grade of finished brick. In 1902, it was sold to the giant Harbison-Walker Company, which transferred Scioto Star's operations to its other nearby plants.

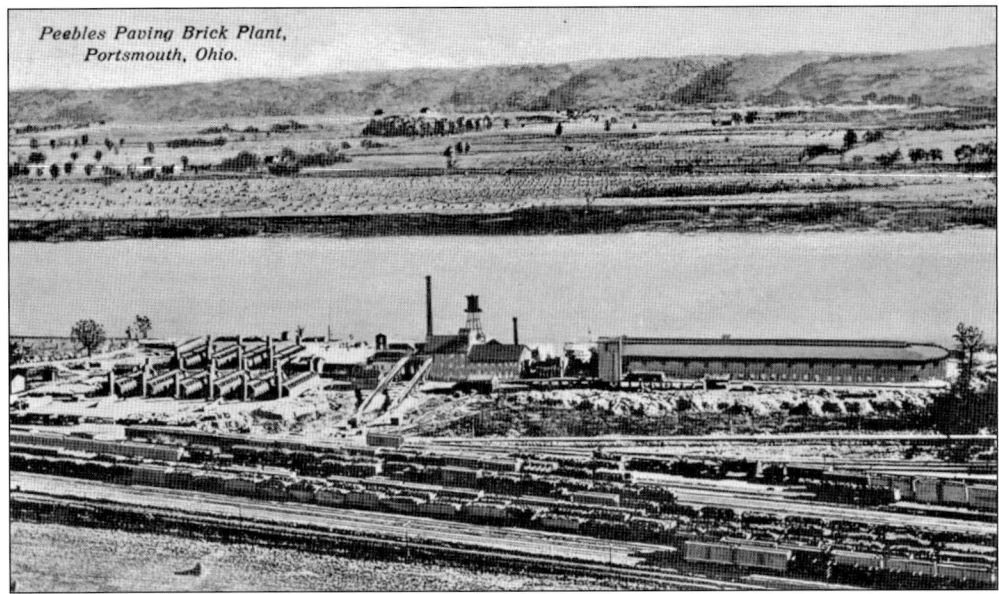

With a capital of $50,000, the Peebles Paving Brick Company was incorporated in June 1902. Two tracts of land west of West Avenue, near the Norfolk & Western and Baltimore & Ohio tracks, were purchased from owners of the Peebles farm. The plant erected there mined clay and shale from the area, currently called Shale Bank Drive. The clay was used to make approximately 60,000 bricks per day.

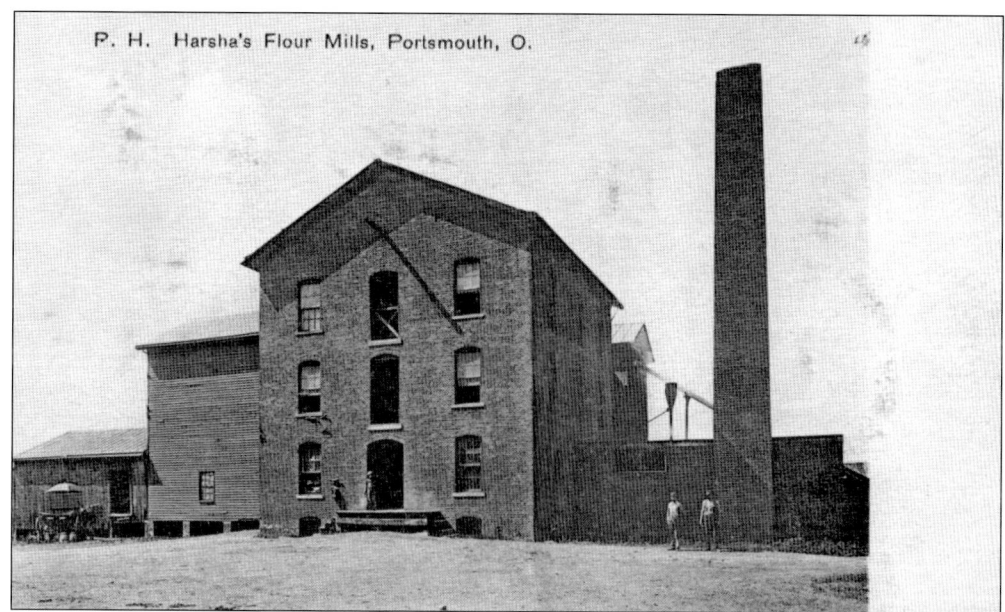

The Harsha & Caskey Flour Mill was built in 1889 and was located on Eighth Street, east of Campbell Avenue. The partnership dissolved in 1901, and the company became known as the P.H. Harsha Mill. Harsha not only manufactured flour, he was also a wholesale dealer in hay and grain. The mill was destroyed by fire in 1954, and the property became the home of Harbison-Walker. (Courtesy Bill Glockner collection.)

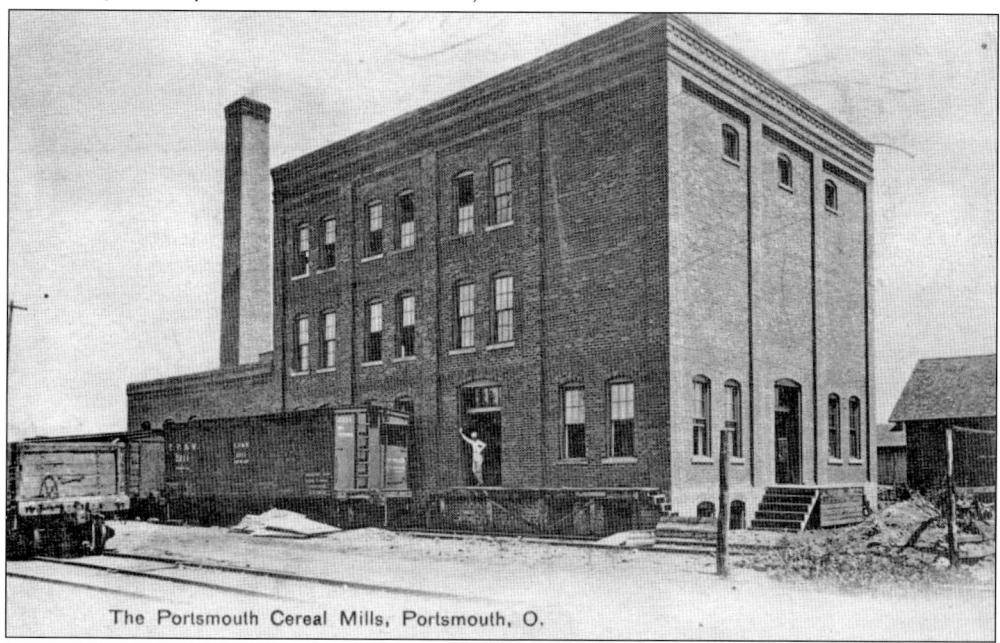

The Portsmouth Cereal Mill was located north of Thirteenth Street, between Chillicothe and Gay Streets. Several businesses have occupied this space since then, including a feed and grain mill and Sterling Stove Company. The building was demolished and Schaefer's Market began doing business at the location until 1966, when it moved to a new building. Since 1967, Clare Cleaners has been located on the property. (Courtesy Bill Glockner collection.)

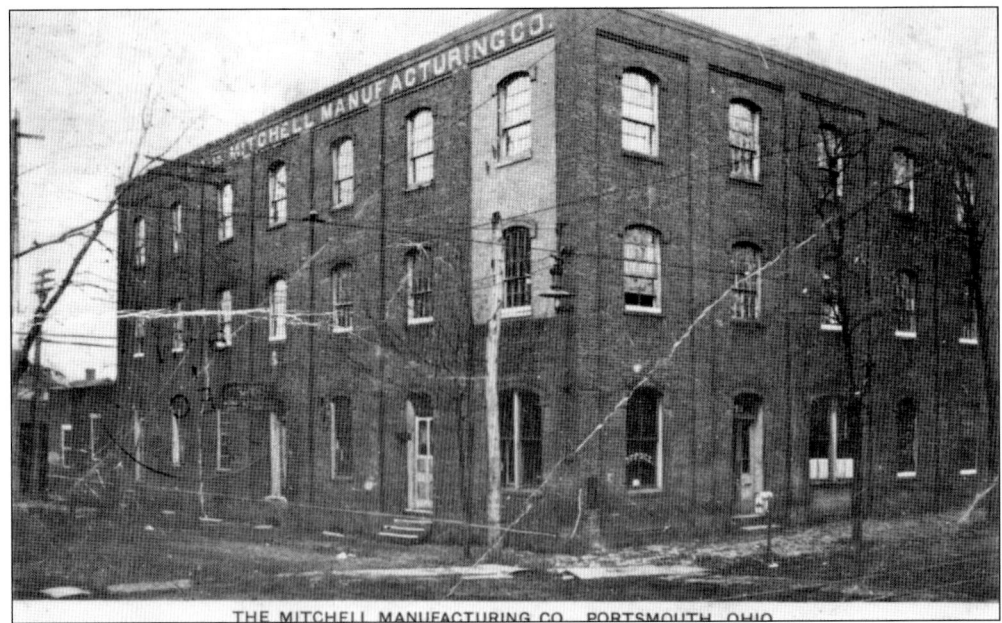

In 1890, Charles Mitchell, a shoe clerk from Tennessee, invented a coin-operated machine to dispense shoelaces. Persuaded by the Selby Shoe Company, he opened the Mitchell Manufacturing Company in 1902 to produce this new device. He quickly expanded operations, developing the shoestrings that would be sold through his machines. The shoestrings became more successful, and the dispenser idea was scrapped in 1909. (Courtesy Bill Glockner collection.)

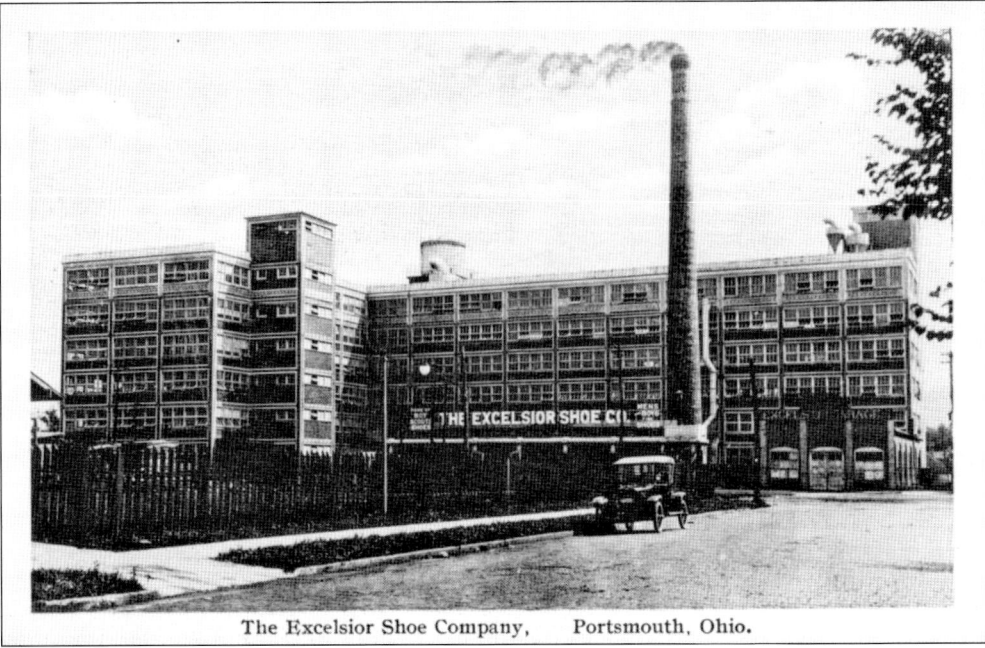

The Excelsior Shoe Company specialized in shoes for boys. In one of its advertising campaigns, the company gave boys who purchased the official Boy Scout Shoe a token with a hole in the top, which was then tied to the shoe. A local store selling the shoes was the Anderson Brothers retail store on Chillicothe Street. Excelsior's 350 skilled employees made 2,000 pairs of shoes daily.

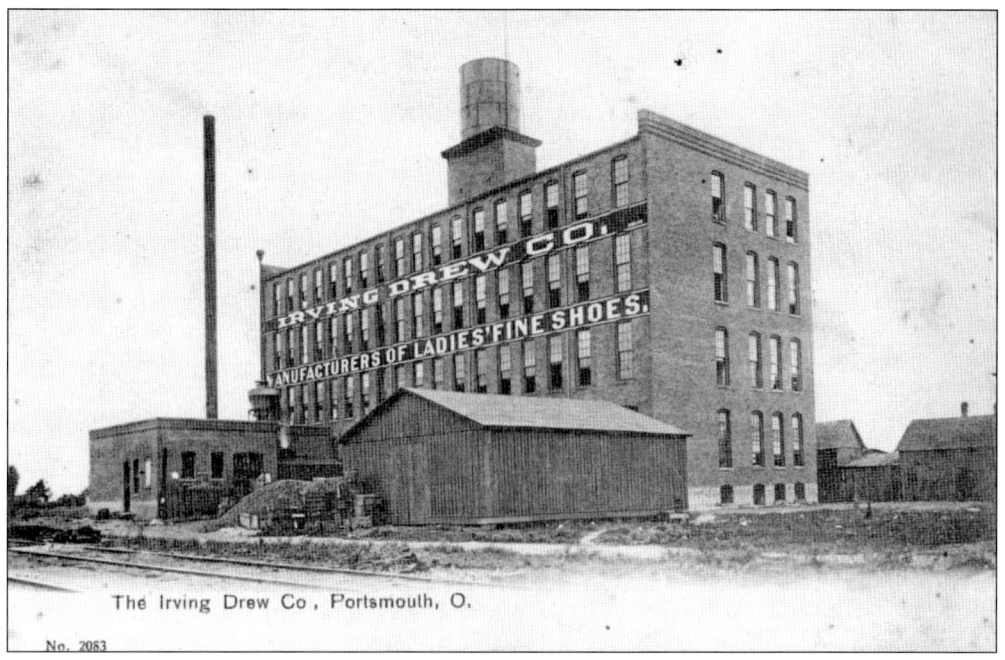

The Irving Drew Company, located on Second Street between Market and Court Streets, was formed in 1877. The company was reorganized in 1879 when George Selby became a partner, and was renamed Drew, Selby, and Company. The firm moved to the northwest corner of Third and Gay Streets in 1881. The new power-driven plant no longer required workers to make shoes by hand or foot power.

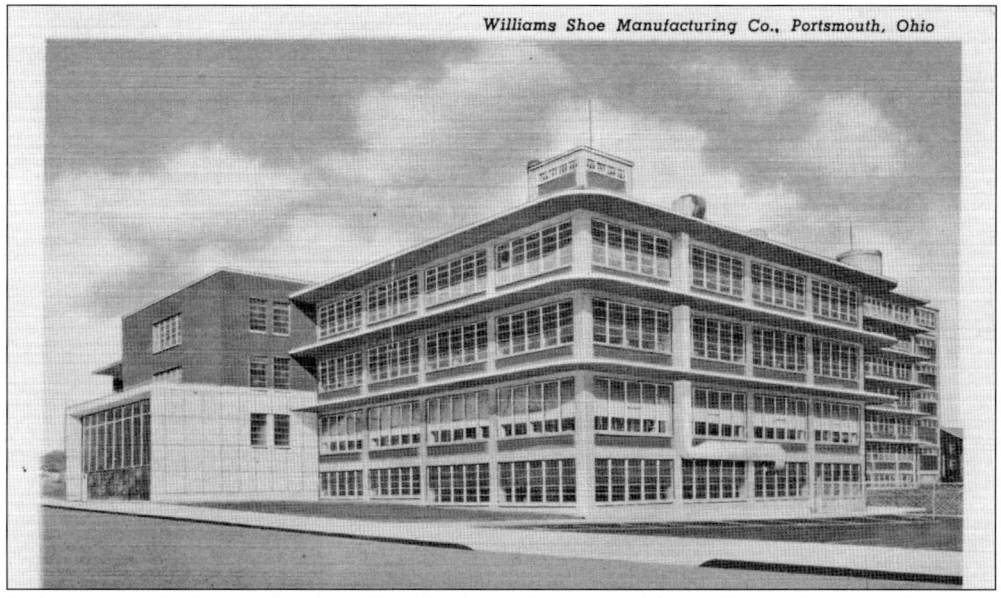

Relocating to the former Excelsior Shoe Company factory in 1929, Williams Shoe Manufacturing was one of the nation's leading producers of medium-priced ladies shoes. Williams partnered with other local manufacturers, such as Vulcan Last, which produced shoe forms and heels, and Patterson Paper Box Company, which made the boxes in which the shoes were shipped locally or nationwide. In 1976, Williams closed and Mitchellace purchased the building.

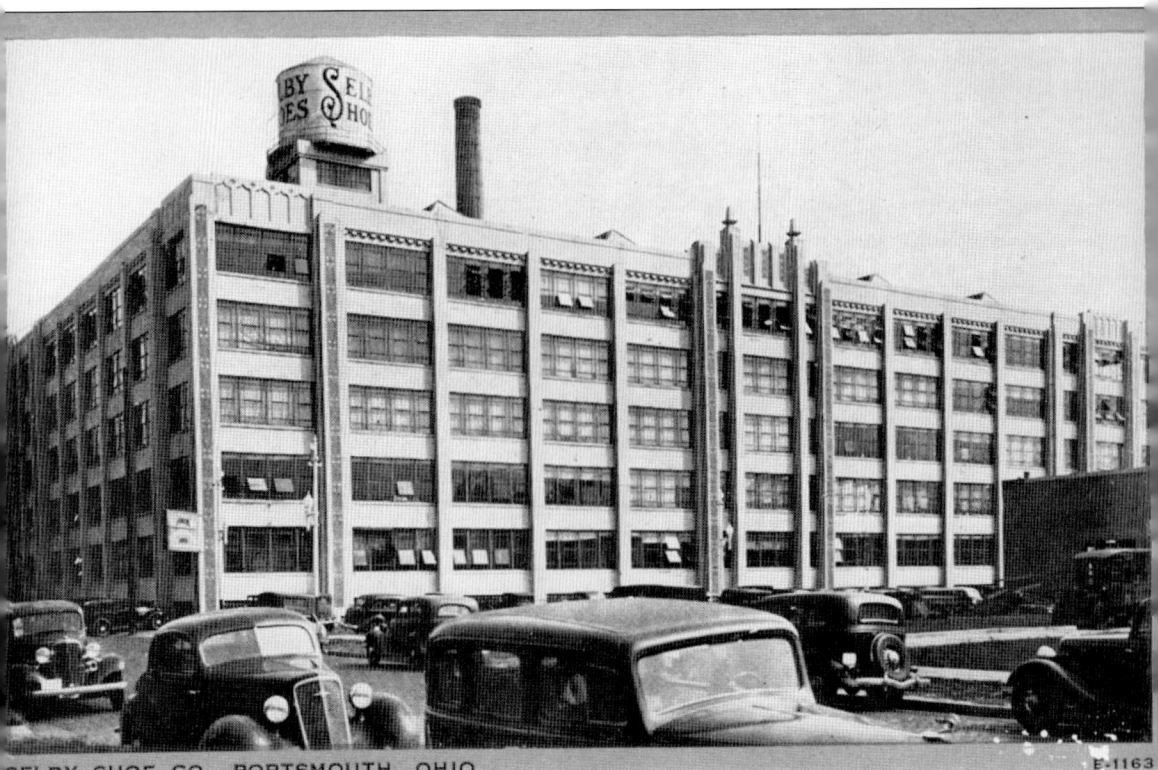

SELBY SHOE CO., PORTSMOUTH, OHIO

In April 1902, the Drew-Selby Company was incorporated. After Irving Drew sold his interest in October 1905, the name was changed to the Selby Shoe Company. At the peak of the shoe industry, Selby's employed approximately 5,500 workers. Located at Seventh and Findlay Streets, the business had a tunnel that ran from Findlay Street to the nearby post office. Faced with declining profits because of a labor strike, overseas competition, and an attempted hostile takeover, the Selby Shoe Company was acquired by Rockwood & Co., which promised to keep the firm operating. Failing to keep its promise, the company closed the doors on the Portsmouth factory in 1957. Williams Manufacturing Co. bought the Selby factory for a warehouse. The building was razed in 1999. (Courtesy Bill Glockner collection.)

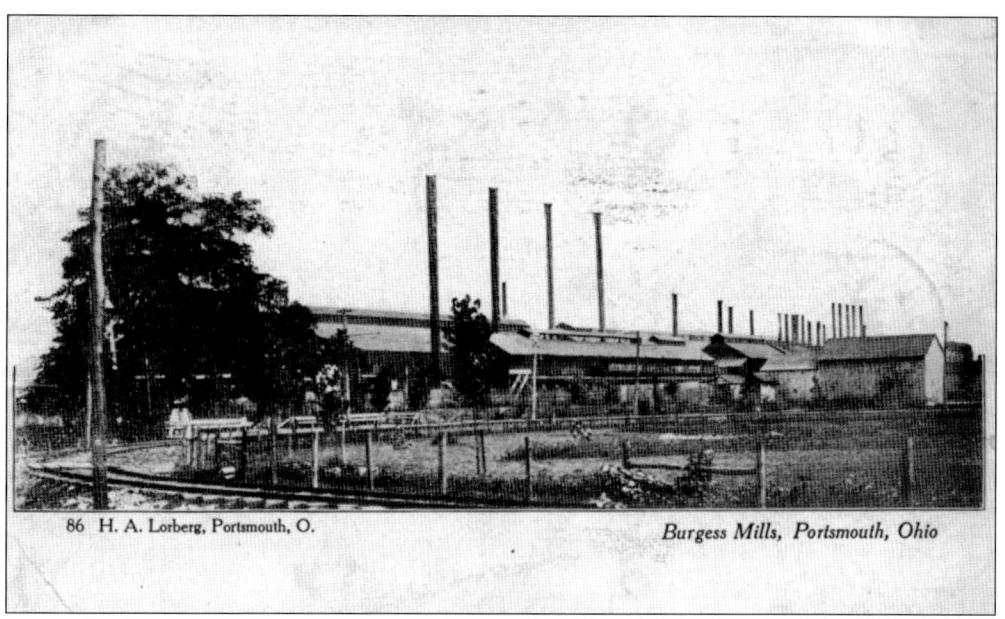

Burgess Steel & Iron Works Company, incorporated in 1872, took over the Portsmouth Iron & Steel Corporation. On June 7, 1898, the entire mill, along with several small buildings in the vicinity, was destroyed by fire. As a result, 800 employees found themselves without jobs. The mill was rebuilt and opened by November 1898 in New Boston. It is shown in this Henry A. Lorberg postcard. (Courtesy Bill Glockner collection.)

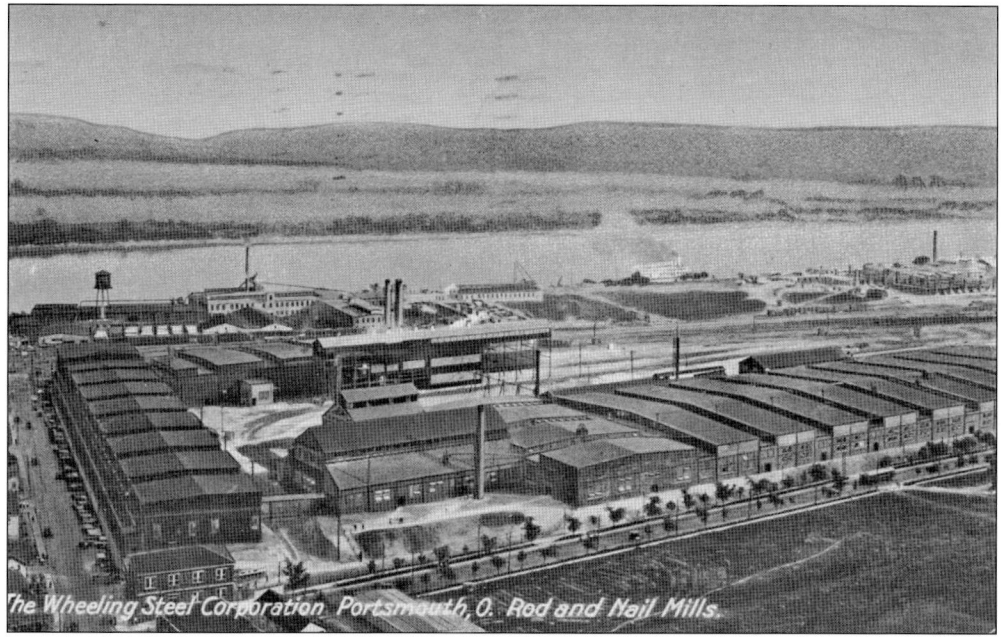

The Wheeling Steel Corporation began operations in 1920, following several reorganizations of steel mills dating back to 1898 on this property just east of Portsmouth. This division alone provided work for more than 1,000 employees during peak operation. During World War II, employees played an important part in the war effort, producing many military items such as 250- and 500-pound bombs that were used in Europe.

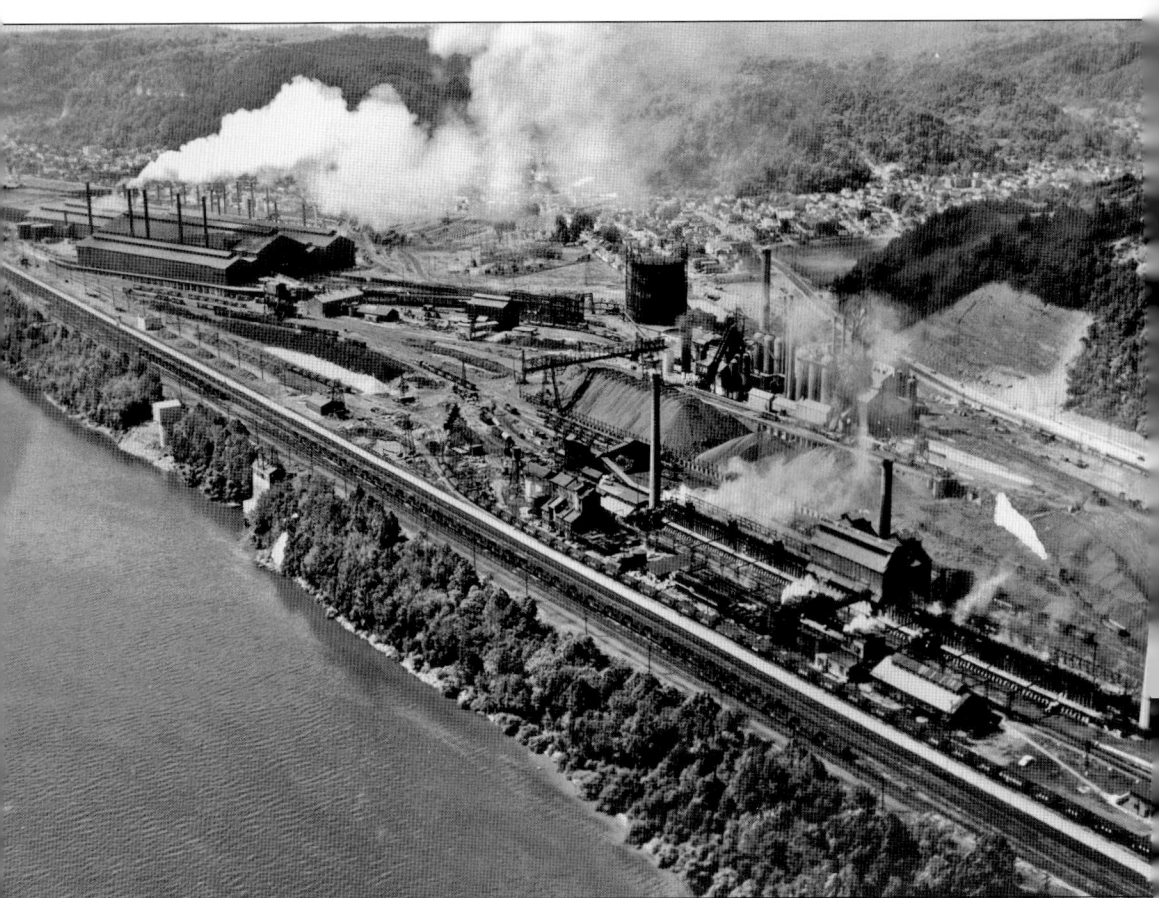

In 1950, Wheeling Steel's Portsmouth Works was sold to the Detroit Steel Corporation. The mill began a period of growth and expansion after more than $150 million was invested in improvements and modernization. In 1951, the facility produced 800,000 tons of steel and employed 4,800 workers, with a monthly payroll exceeding $1.25 million. The coke plant, rebuilt and modernized in 1965, was considered the "most modern and complete" in the industry. In 1969, due to foreign competition and outdated technology, Detroit Steel was sold to Pittsburgh's Cyclops Corporation. By September 1980, the mill, known as Empire-Detroit Steel Divison of Cyclops, began selling off equipment, and the mill was closed. In 2002, the coke plant, which had remained an independent operation, closed due to a combination of issues, including a bad economy.

Two

Health Care

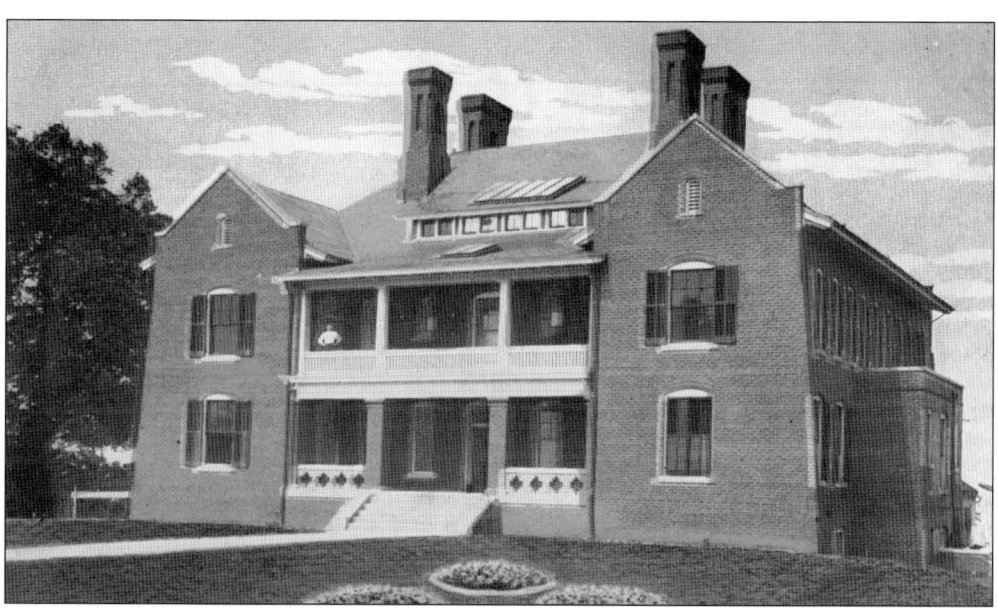

City Hospital was located on the west side of old Chillicothe Pike (Scioto Trail). It opened in February 1870 in a reputedly haunted building. Thomas Dugan, the previous owner of the three acres of property, sold it to the city for $5,000. The building was turned into a children's home four years later, and the community was without a hospital for 30 years after its closing.

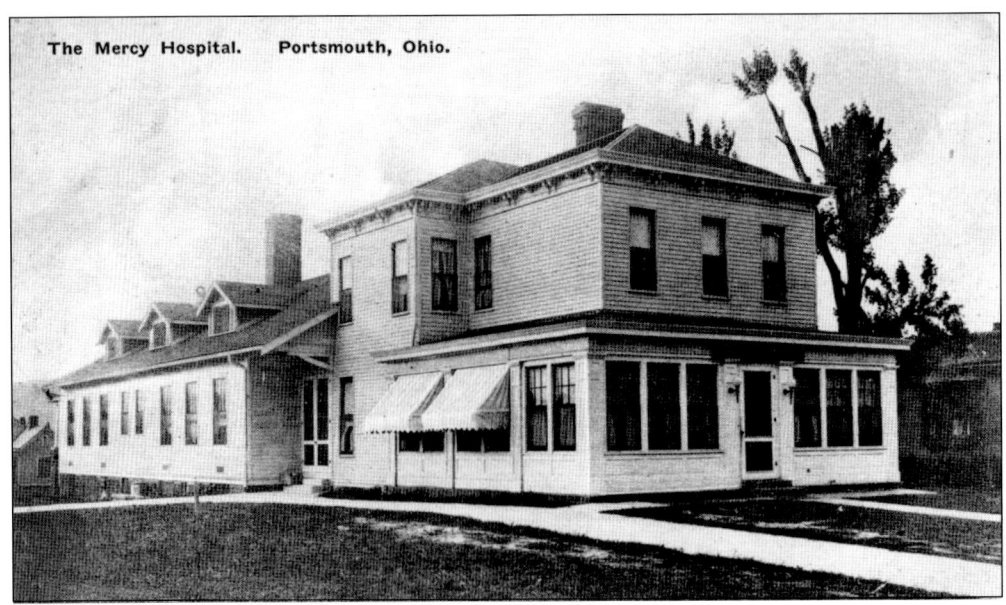

In 1921, Mercy Hospital was opened in a home donated by John Baron. The Sisters of St. Francis from Rochester, Minnesota, ran the 27-bed hospital. After the new Mercy Hospital was built, this became a home for the Sisters and was named Jarleth Hall. The Sisters had established the Mercy Hospital Clinic on Gallia Street prior to opening the hospital. (Courtesy Bill Glockner collection.)

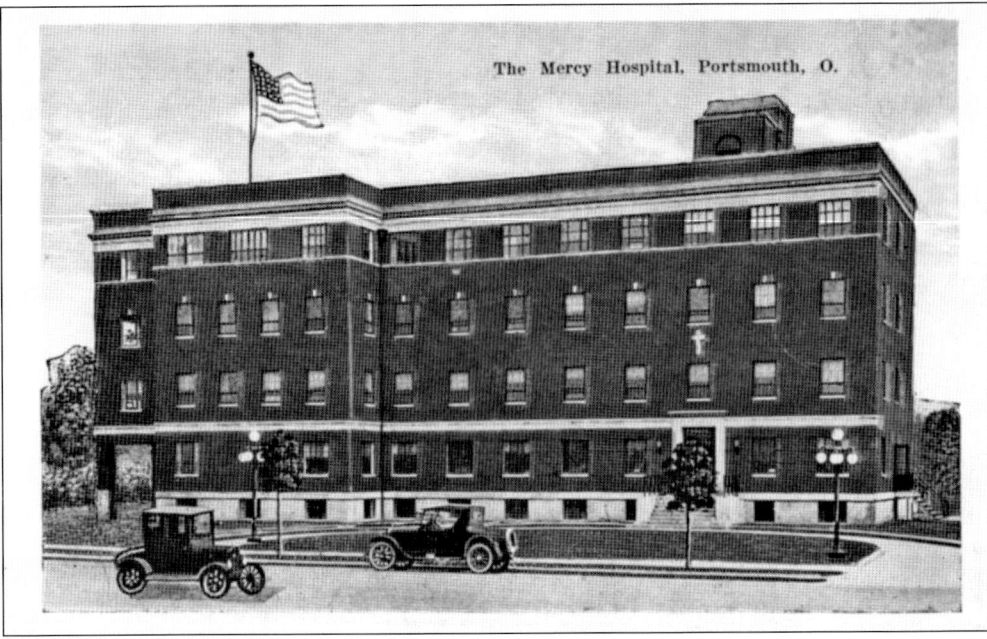

Answering the growing needs for medical care, construction on a five-story brick hospital began in 1923 on Kinneys Lane. The new Mercy Hospital provided 50 beds, and immediately began a training program for nurses. Nearly 400 nurses graduated from the program, including Sister Mary Jarleth Connelly, for whom Jarleth Hall was named. In 2001, the building was razed, but the former emergency room was spared. It is still in use as an urgent care facility.

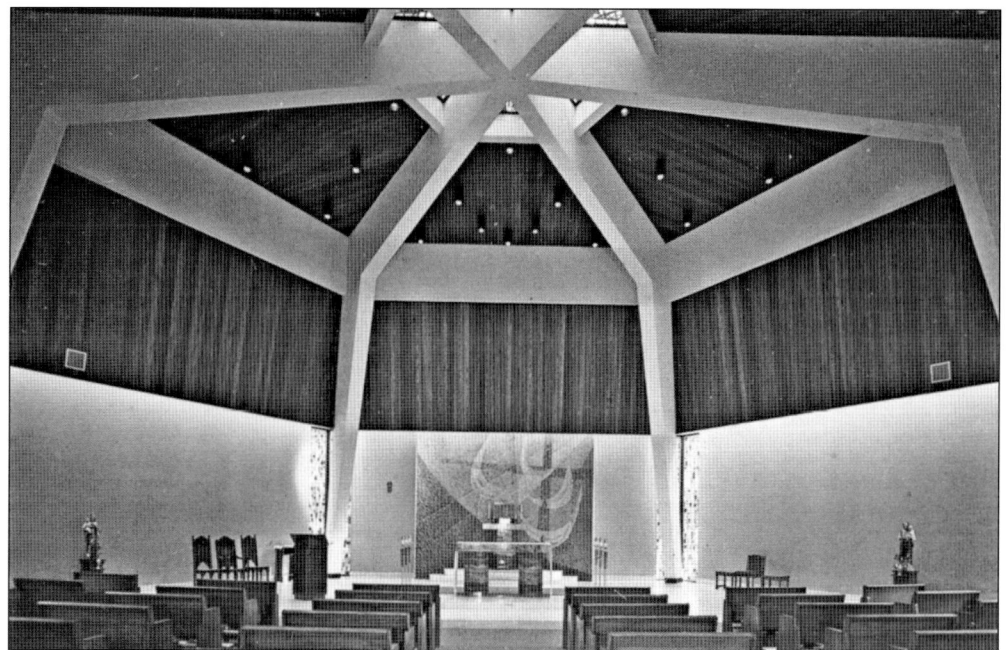

The back of this postcard reads: "Our Lady of Mercy Chapel, Mercy Hospital Portsmouth, Ohio. The mosaic behind the marble altars represents the Stigmata of St. Francis of Assisi. The chapel windows and skylight, made of faceted glass, vividly reflect the light. The sanctuary windows illustrate praise, thanksgiving, petition, and reparation."

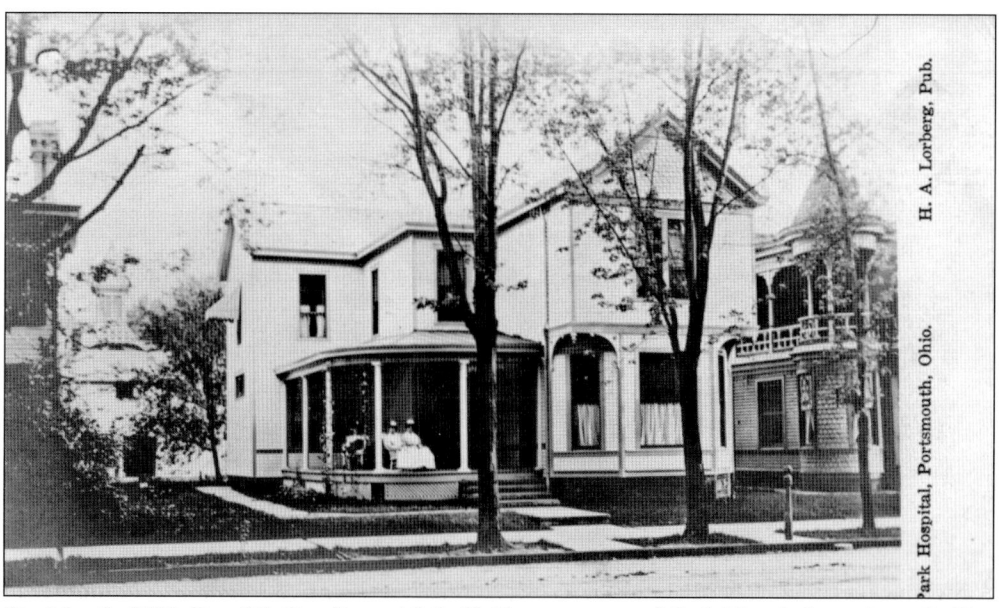

On May 2, 1902, Drs. J.S. Rardin and S.S. Haldarman opened Park Hospital, a private facility located at 44 East Ninth Street, facing Tracy Park. The hospital helped with the overwhelming needs of the sick and injured seeking medical care. Containing 20 beds, it was the only area hospital until City Hospital was reopened as Hempstead Hospital. (Courtesy Bill Glockner collection.)

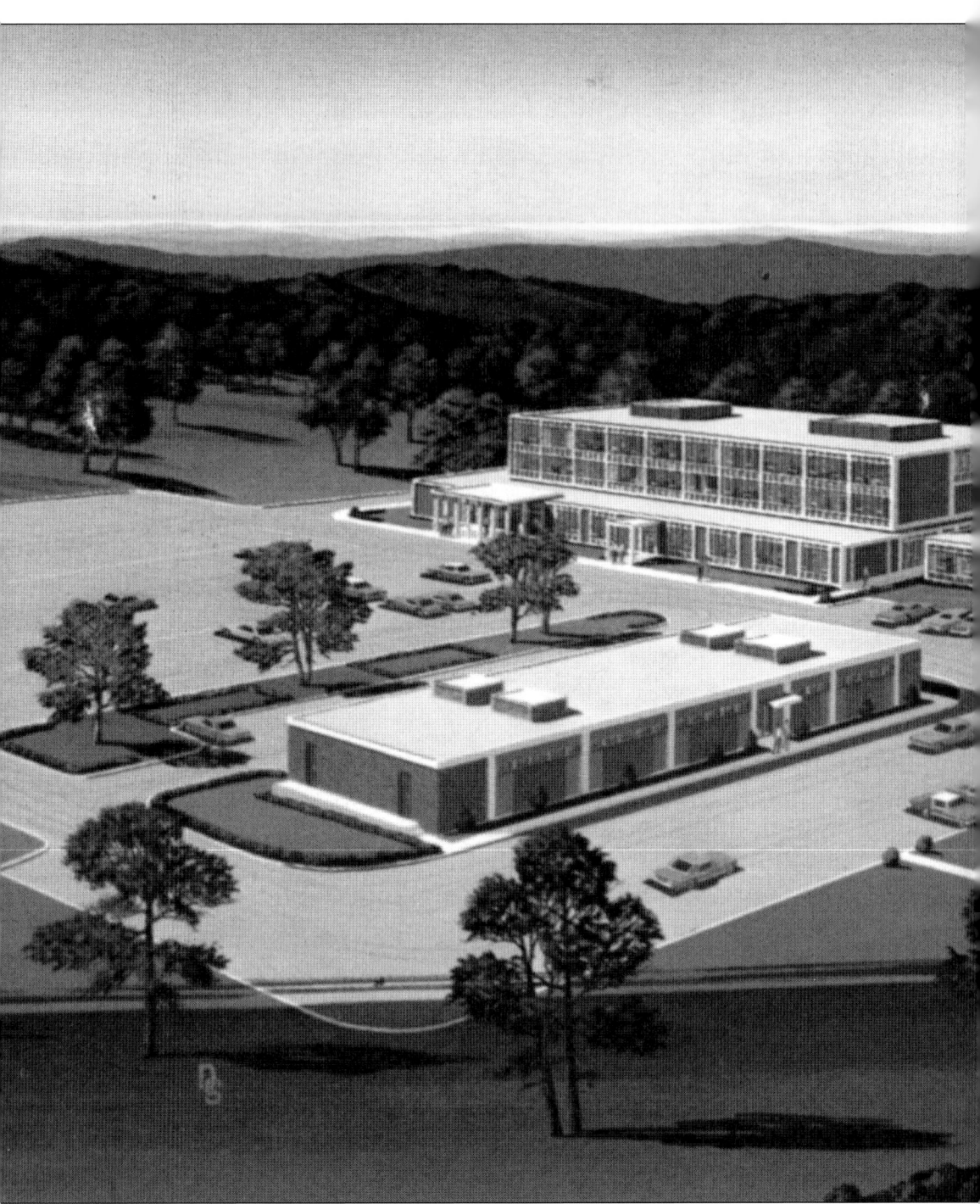

Scioto Memorial Hospital opened its doors in July 1968 after years of dedication and hard work. In the 1980s, Southern Hills, Mercy, and Scioto Memorial Hospitals merged under the name Southern Ohio Medical Center (SOMC). Since that time, SOMC has seen several expansions, complete with the latest in surgical, emergency, maternity, and critical care services. The front entrance was remodeled and includes a four-story tower with private rooms. Doctors, using state-

of-the-art equipment, provide SOMC with the capability of doing open-heart and other surgical procedures without the patient leaving Scioto County. One of the area's largest employers, its staff of over 2,000 extends care to inpatients and those receiving outpatient services. SOMC is recognized as a magnet hospital. Only four percent of hospitals in the United States can claim this distinction. (Courtesy Bill Glockner collection.)

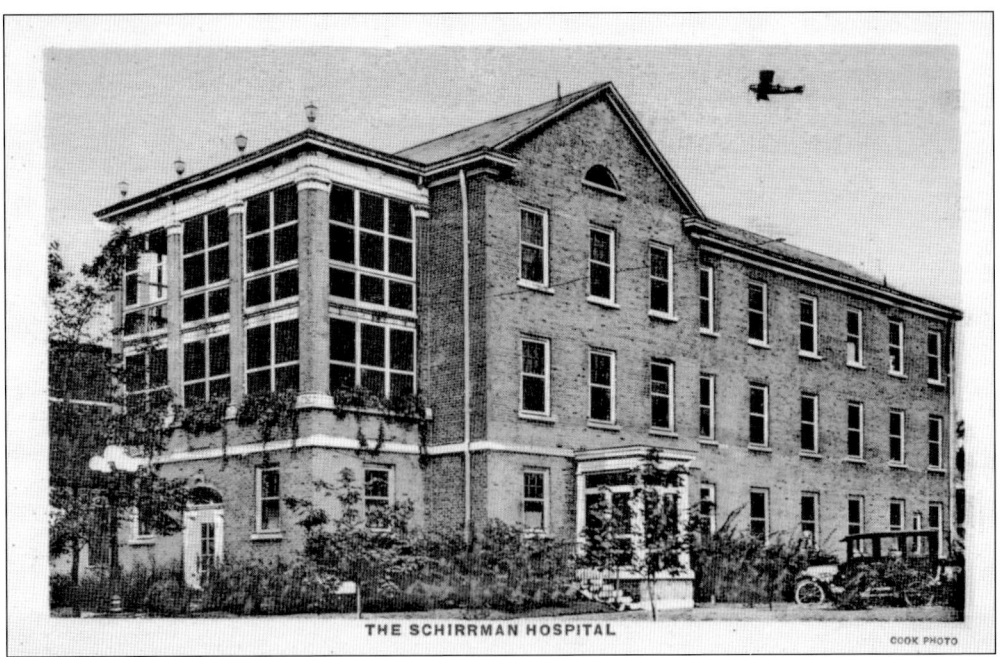
THE SCHIRRMAN HOSPITAL

In 1920, Dr. Harry Schirrman opened a private, 50-bed hospital in an annex to his home at Eighth and Chillicothe Streets. The hospital claimed to have the most up-to-date equipment, including a call-light system. After 22 years of serving his community, Dr. Schirrman announced he was closing the hospital. Charles Smith and Clyde Everett reopened it four years later as a public, nonprofit hospital.

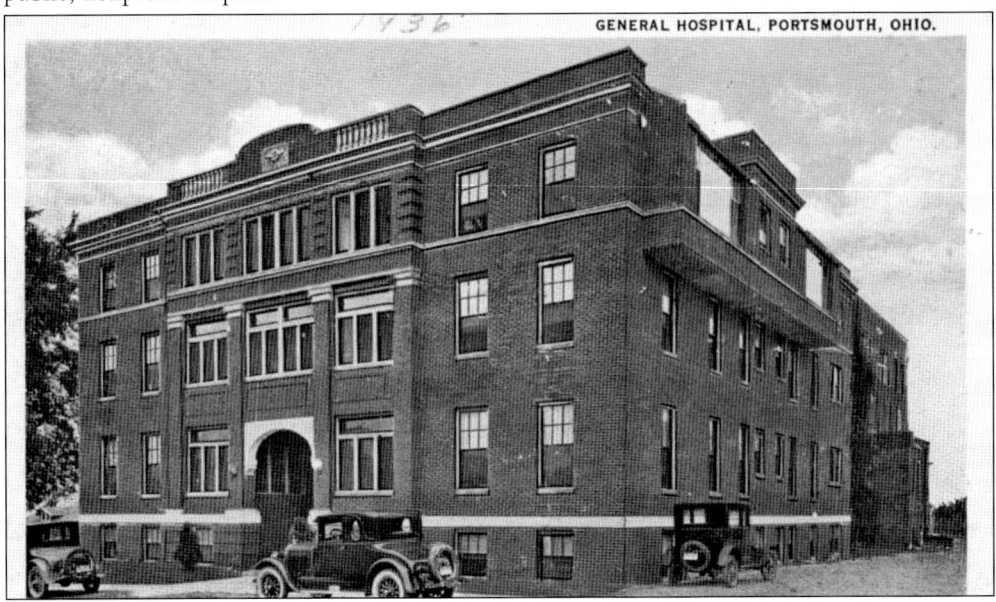
GENERAL HOSPITAL, PORTSMOUTH, OHIO.

In 1923, the city council voted on a $100,000 bond to enlarge and improve the Hempstead Hospital (formerly the City Hospital). The third floor was elevated and two wings were added prior to the May 12, 1925, dedication, increasing the bed capacity to 60. Hempstead Hospital, which was named in honor of Dr. Giles S. Hempstead, was then renamed General Hospital. Later converted to apartments, the building was razed in 2007.

Three

Transportation

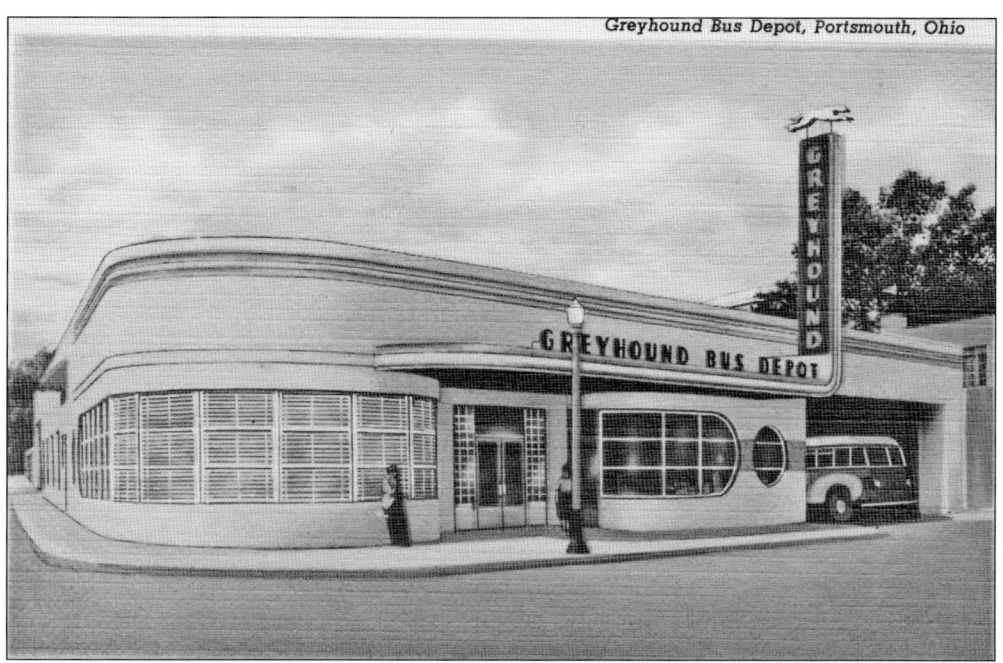

The Greyhound Bus Depot, located at Gallia Street and Moulton Place, was completed on December 13, 1941. The busiest years for the bus line were during World War II, when gasoline was being rationed. The station included a well-patronized lunch counter that served fish sandwiches or grilled cheese sandwiches for only 20¢. The Greyhound station closed in February 1986 and was razed on September 26, 2008.

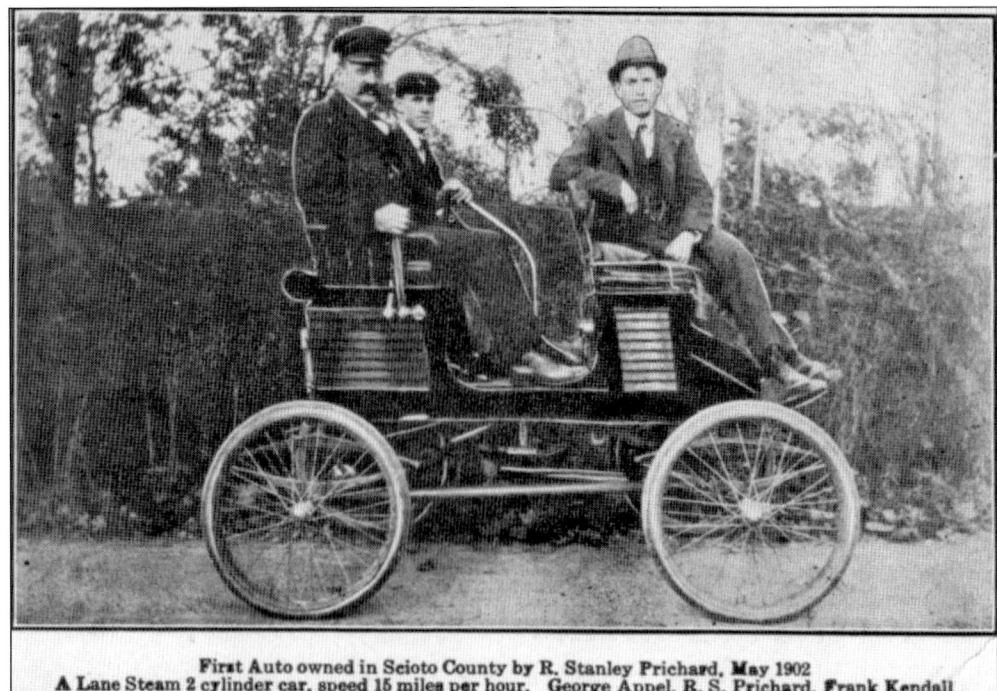

First Auto owned in Scioto County by R. Stanley Prichard, May 1902
A Lane Steam 2 cylinder car, speed 15 miles per hour. George Appel, R. S. Prichard, Frank Kendall

The first automobile owned by a resident of Scioto County was introduced in May 1902. Shown in the car from left to right are George Appel, owner R.S. Prichard, and Frank Kendall. Assembled in Poughkeepsie, New York, the Lane Steam two-cylinder vehicle was painted bright red and had a maximum speed of 15 miles per hour. (Courtesy of Bill Glockner collection.)

This c. 1900 Portsmouth residence was in fact a tollhouse that collected money on the Portsmouth-Chillicothe Turnpike. It was located at the bottom of Two Mile Hill, on Scioto Trail just north of Coles Boulevard. Traders and travelers were required to stop and pay a wide-ranging fee based on contents and the means of transportation. Sunday churchgoers, the military, and funeral attendees were allowed to pass for free.

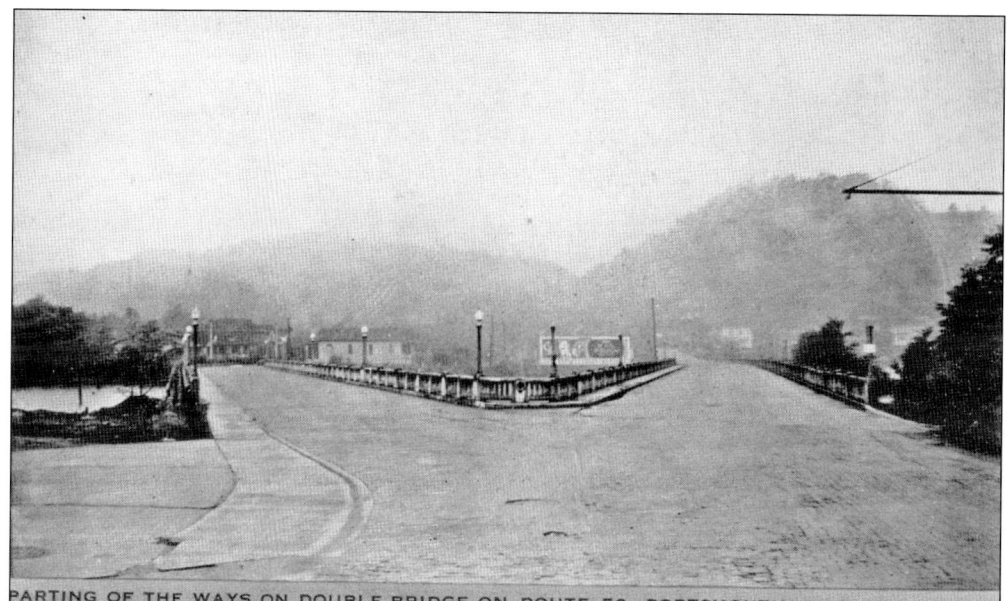

Constructed around 1930, this unique bridge east of Portsmouth was known as the "Y Bridge." In this west-facing photograph, Route 52 divides into Rhodes Avenue to the left and Gallia Street to the right. All streets featured two-lane traffic, which eventually saw much congestion as automobiles became more prevalent. A new, four-lane roadway was built in 1961 to replace the bridge. (Courtesy of Bill Glockner collection.)

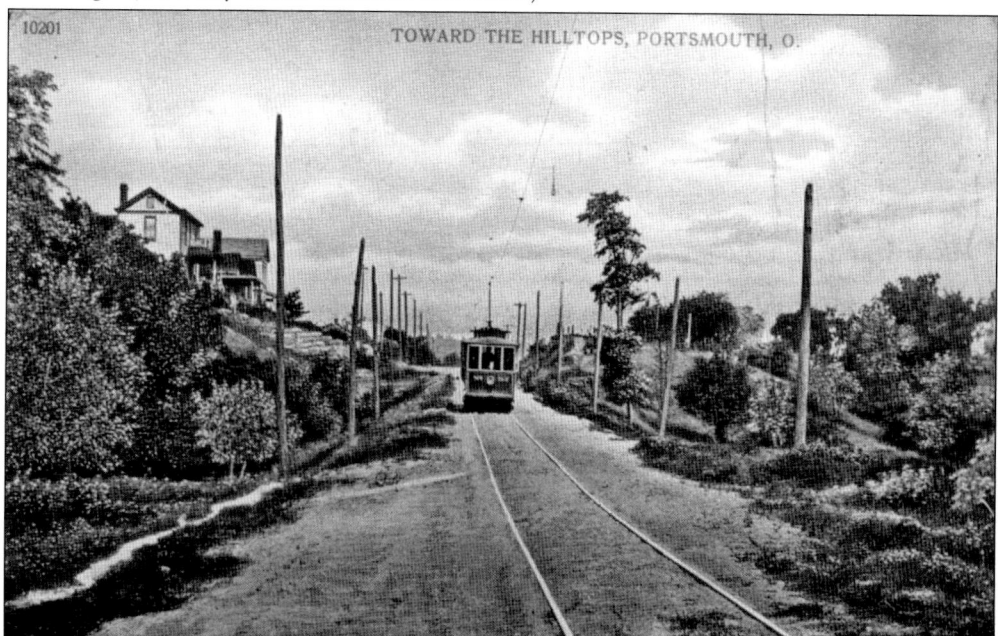

Electric streetcars were introduced to Portsmouth in 1892, replacing the horse-drawn cars that began service in 1877. Operating on nearly 15 miles of tracks, the system provided the most efficient form of transportation in the early 1900s. Here, a streetcar is seen on Seventeenth Street. An increase in the use of automobiles spelled doom for the 61-year-old operation, which ceased on January 12, 1938. (Courtesy of Bill Glockner collection.)

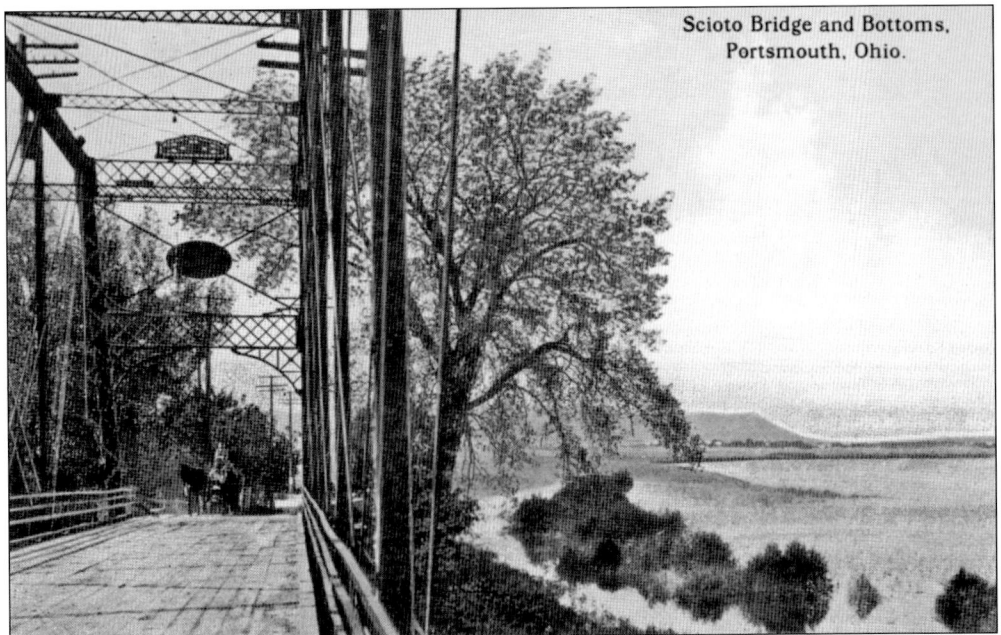

A team of horses pull a wagon from West Portsmouth across the Scioto River Bridge at Second Street around 1910. Constructed following the May 1884 collapse of a suspension bridge that killed two children, this bridge—the fifth at this location—also met an untimely end. During the March 1913 flood, it was completely washed away. The disaster resulted in no fatalities.

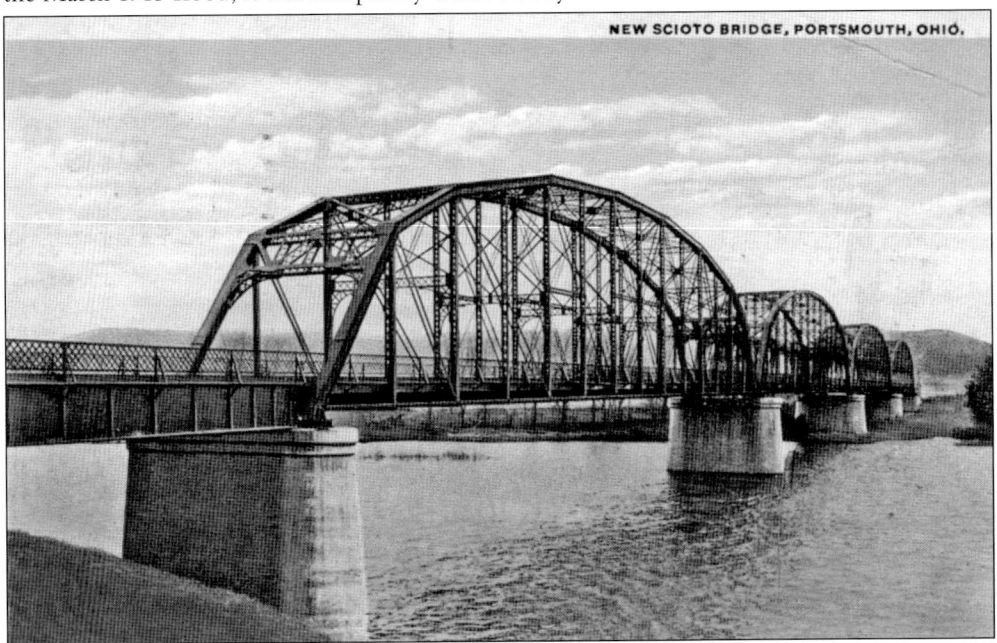

Opening for traffic in November 1915, the $300,000 "new" Second Street Scioto River Bridge replaced the one destroyed by the 1913 flood. It was the sixth bridge to occupy this site. Surviving multiple floods during its lifetime, it lasted much longer than its predecessors. Due to its deteriorating condition, it was closed in December 1997 and razed a month later. Another bridge, completed in 1999, occupies this spot today.

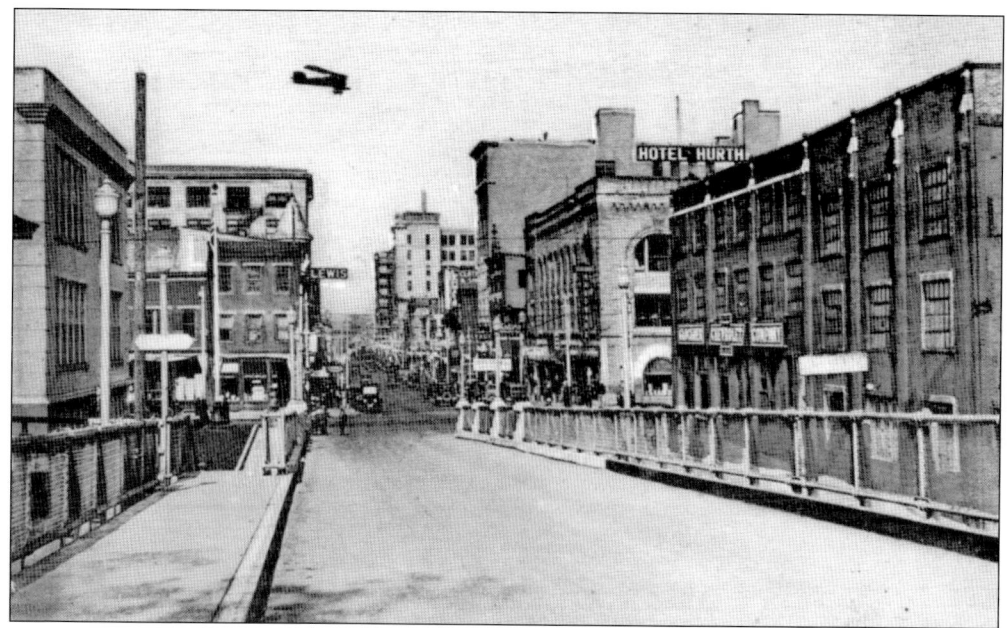

The view in this 1930s postcard is from the recently completed U.S. Grant Bridge, looking north at downtown Portsmouth in its glory days. Visible on the left are Massie School and Lewis Furniture, while on the right are the Hurth Hotel, Glockner Hardware, and the Glockner Chevrolet building. While most of the foreground buildings were gone by the end of the 20th century, many of those in the background survived.

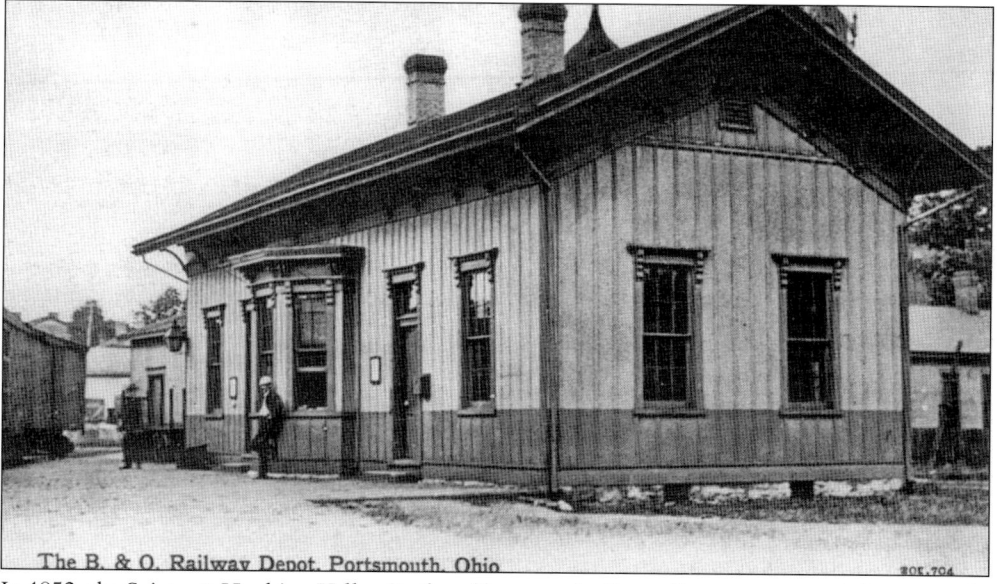

In 1852, the Scioto & Hocking Valley Railroad became the first railway to operate in Portsmouth. The route, extending northeast toward Jackson, featured both freight and passenger trains. It was later known as the Baltimore & Ohio Railroad. Shown here is the B&O depot on Market Street in Portsmouth around 1920. The last passenger train on this railroad ran in December 1946, and the last freight train operated around 1972. (Courtesy Bill Glockner collection.)

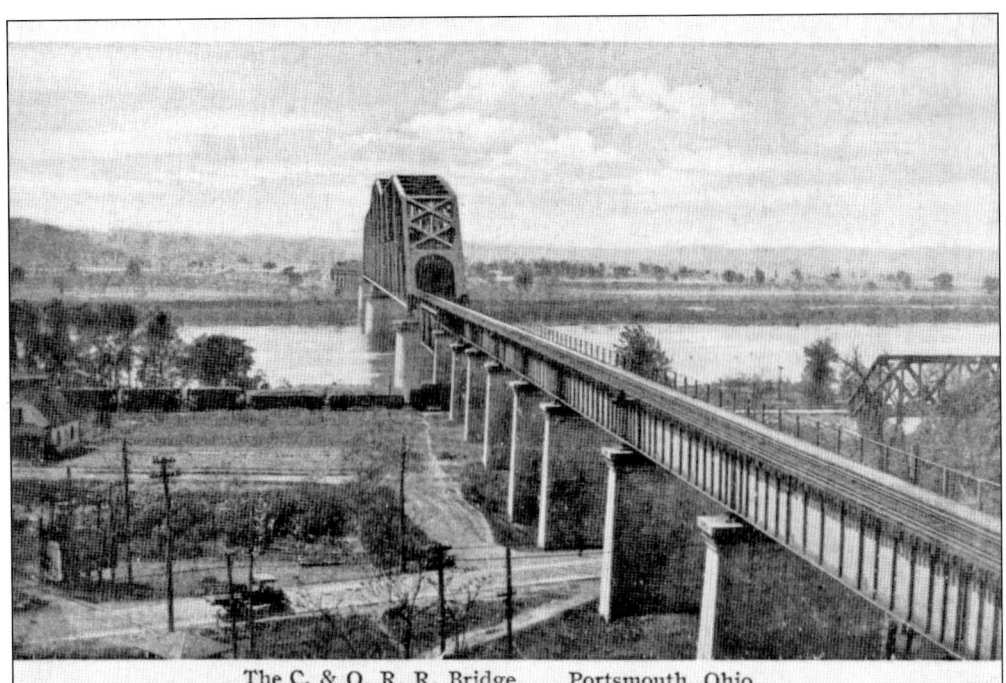

The C. & O. R. R. Bridge, Portsmouth, Ohio.

The massive Chesapeake & Ohio Railroad Bridge at Sciotoville was considered an engineering marvel when it opened for operation in July 1917. Crossing the Ohio River toward Limeville, Kentucky, the bridge took nearly three years to construct. With a main span of over one-fourth of a mile in length, it was the longest continuous truss bridge in the world when it was completed, and for nearly 20 years afterward. Still in use today by CSX Transportation, the double-track mainline bridge continues to carry tons of coal and freight between two of the railroad's major terminals in Russell, Kentucky, and Columbus, Ohio.

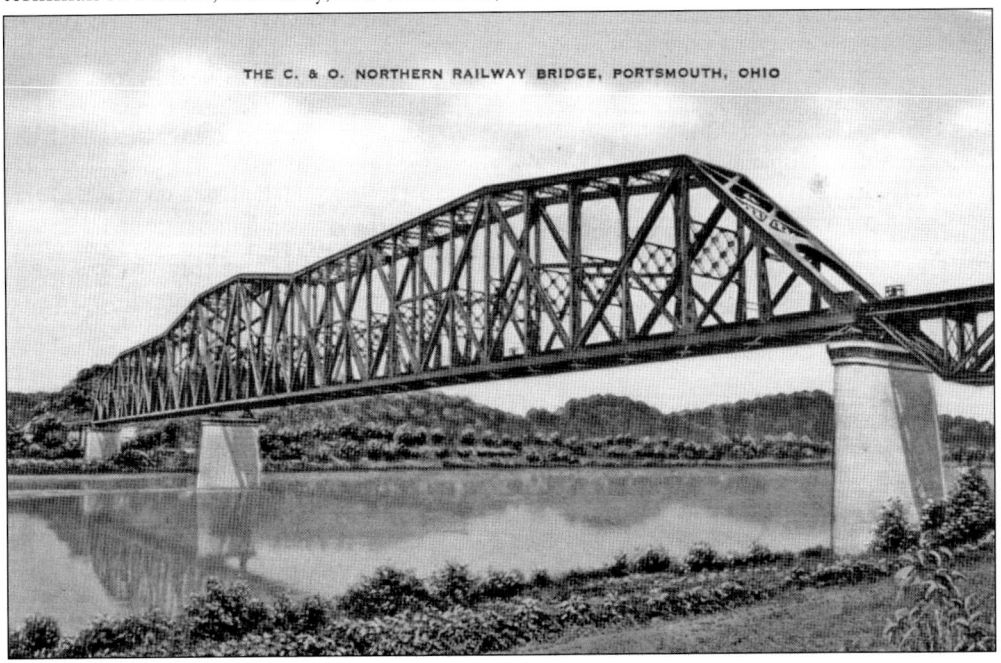

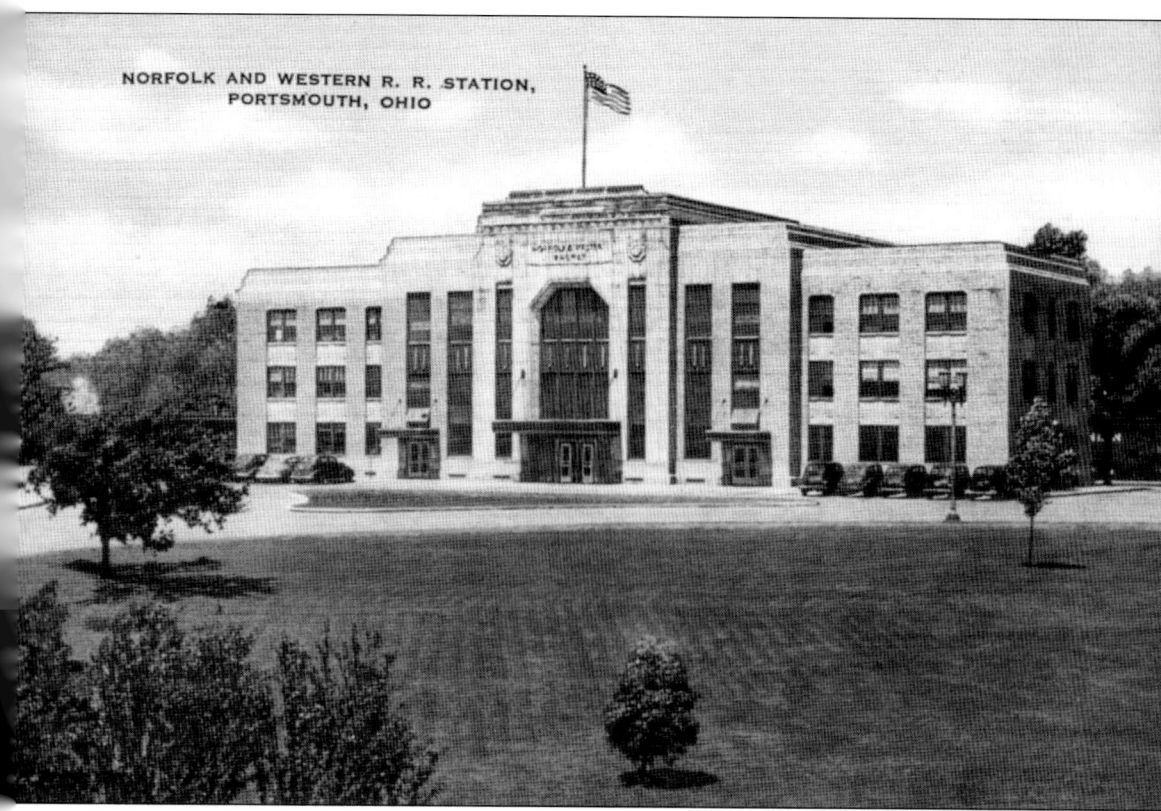

The Norfolk & Western Railway passenger station was completed on July 1, 1931. Located on Sixteenth Street, the thoroughly modern facility featured all of the amenities available at the time. During the 1937 flood, despite waters almost reaching the second floor, the building was surprisingly and heroically called into action as an emergency communications and distribution center for the city. At the peak of rail travel during World War II, as many as 12 passenger trains arrived and departed daily. For some area soldiers, this building would sadly be their final contact with their hometown. The structure also served as the headquarters of the railroad's Scioto Division, which oversaw operations from Williamson, West Virginia, to Cincinnati, Columbus, and, later, Bellevue, Ohio. Dispatchers, draftsmen, and maintenance personnel, as well as supervisors and their staffs, had offices in this building. After the last passenger train departed on May 1, 1971, the structure continued functioning as an office building. Due to restructuring and relocation of operations, the building closed in late 2002 and was razed in April 2004.

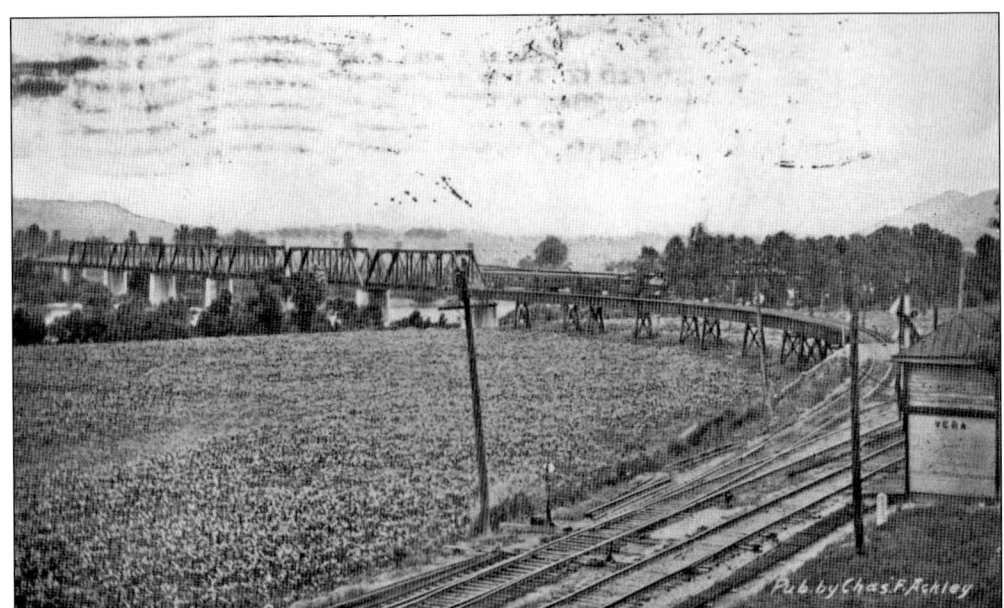

Vera Junction, as seen in this 1910 postcard, was located on Portsmouth's north end and was an important area for the Norfolk & Western Railway. Tracks from beyond the Appalachia coalfields and through Portsmouth divided at Vera, with one track going toward Cincinnati and two tracks going toward Columbus. Operators in the interlocking tower on the right controlled the turnouts and signals for this active area. (Courtesy Bill Glockner collection.)

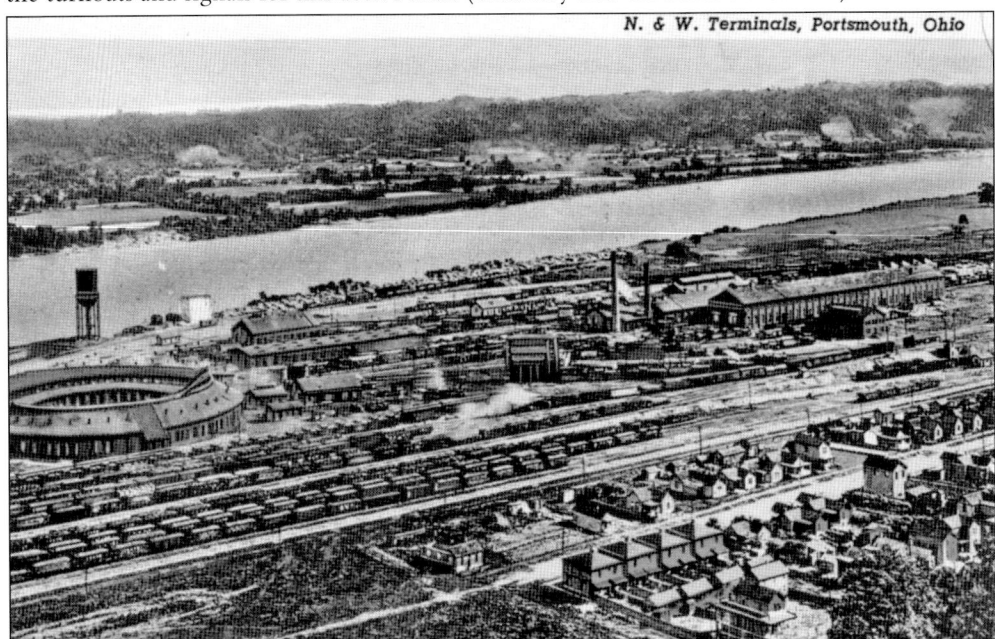

An enormous campaign began in 1900 to persuade the Norfolk & Western to relocate its yard operations from Kenova, West Virginia, to Portsmouth. Local leaders and citizens collectively purchased nearly 140 acres of land and donated it to the railroad. The strategy worked, and the massive Portsmouth Yards opened in 1903. For a brief time, it was the largest railroad yard in the world, employing thousands of Portsmouth-area residents.

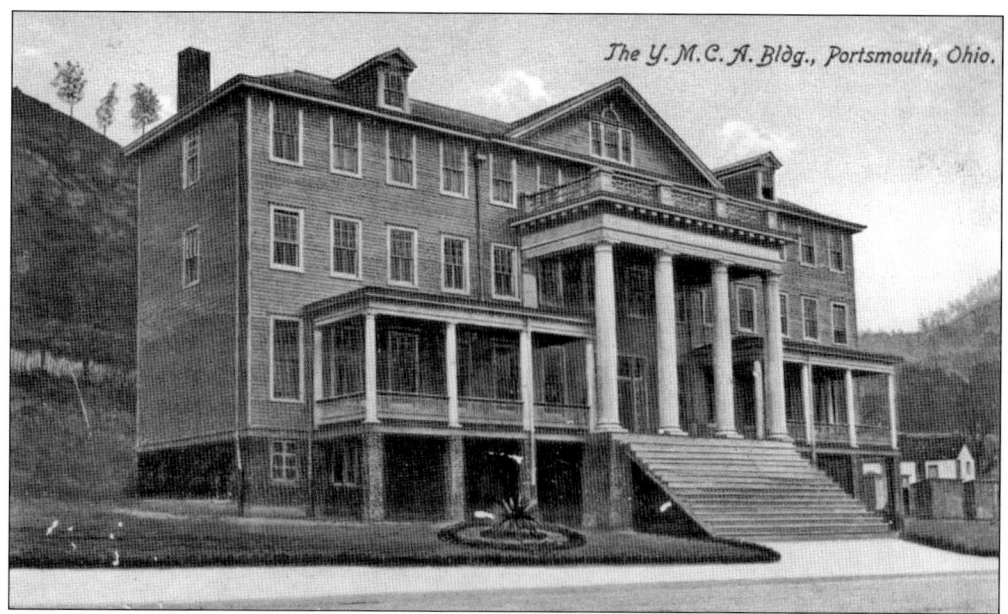

Constructed in 1908 by the Norfolk & Western Railway, the Railroad YMCA building stood at 2829 Gallia Street, directly across from the vast N&W terminals. Containing sleeping quarters and recreational facilities for employees, the facility remained in service for over half a century. In 1960, the structure was leased and remodeled as the Homestead Restaurant and then the Cavalier Restaurant before closing for good and being razed in 1968.

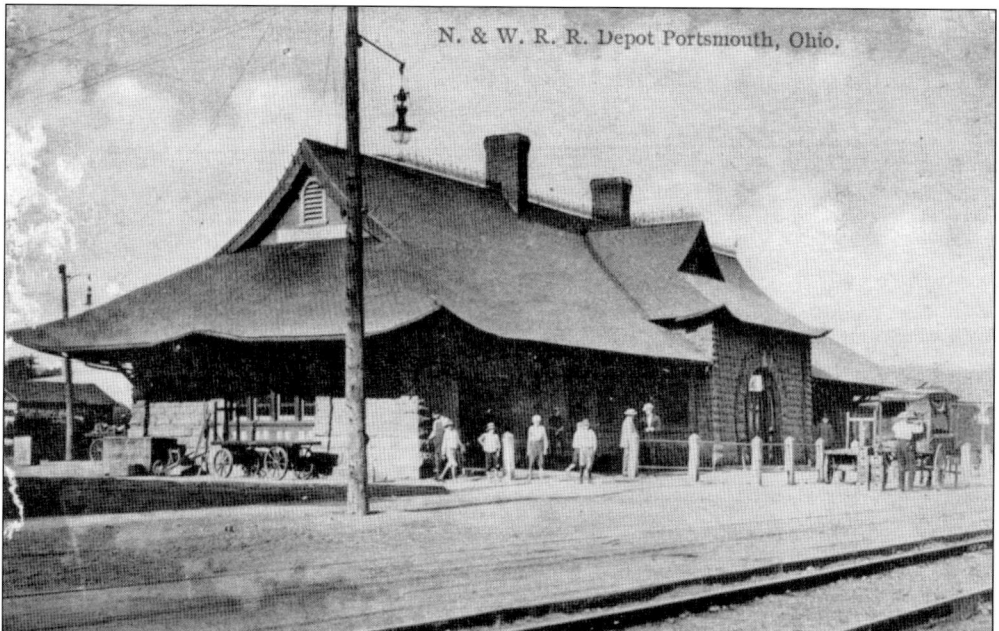

Constructed by the Cincinnati & Eastern Railroad in 1886, this depot was located on the northwest corner of Tenth and Waller Streets. Changing ownership several times until acquired by Norfolk & Western in 1901, the building served as its passenger depot until 1931, when the station on Sixteenth Street was constructed. The building was then used as storage for the railroad's signal department until it was razed in 1968. (Courtesy Paul O'Neill collection.)

Three forms of competing transportation are shown northwest of Portsmouth in this 1907 postcard. At left is the Portsmouth & Galena Turnpike (later State Route 104), at center is the Ohio and Erie Canal, and on the right is the Norfolk & Western Railway. The canal, completed in 1832 and extending to near Cleveland, fought its two growing competitors boldly until the early 1900s, when machinery and the 1913 flood proved triumphant. (Courtesy Paul O'Neill collection.)

Along the Ohio and Erie Canal northwest of Portsmouth is this interesting scene from 1903. Spanning Scioto Brush Creek are both the canal (using an aqueduct) and the roadway (via one of 80 covered bridges in Scioto County at the time). While this scene is just a memory today, the lumber removed from the covered bridge survives as a barn, located parallel to State Route 104. (Courtesy Paul O'Neill collection.)

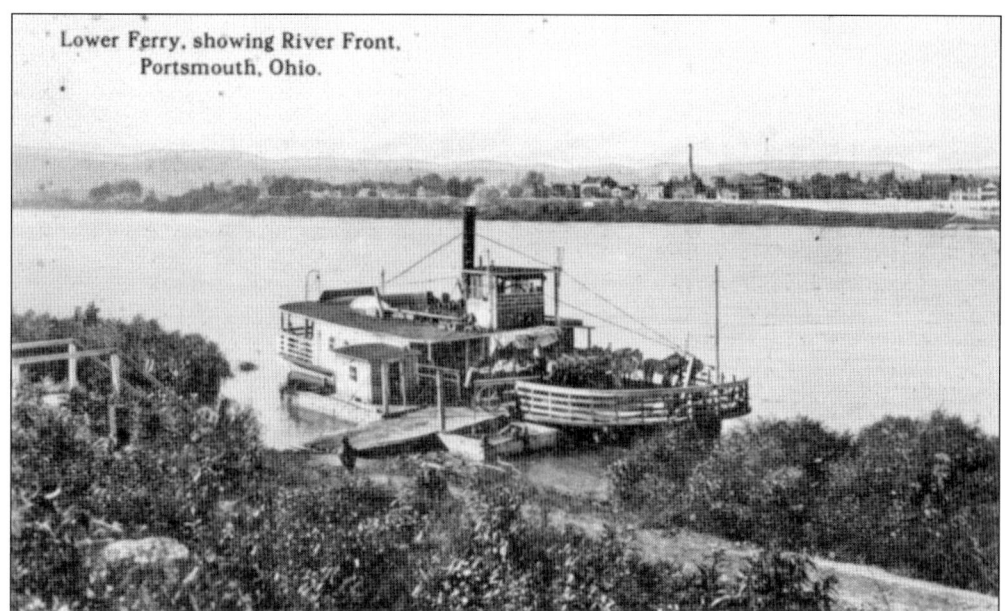

One of the many ferry boats that operated at Portsmouth was the *Chesapeake*, which began operations in 1904. It was also known as the Lower Ferry. Operating between the Court Street landing and South Portsmouth, Kentucky, the *Chesapeake* was owned by the Chesapeake & Ohio Railroad. When the Grant Bridge opened in 1927, the boat was sold to a ferry operation in Manchester, Ohio. It was destroyed by fire four years later.

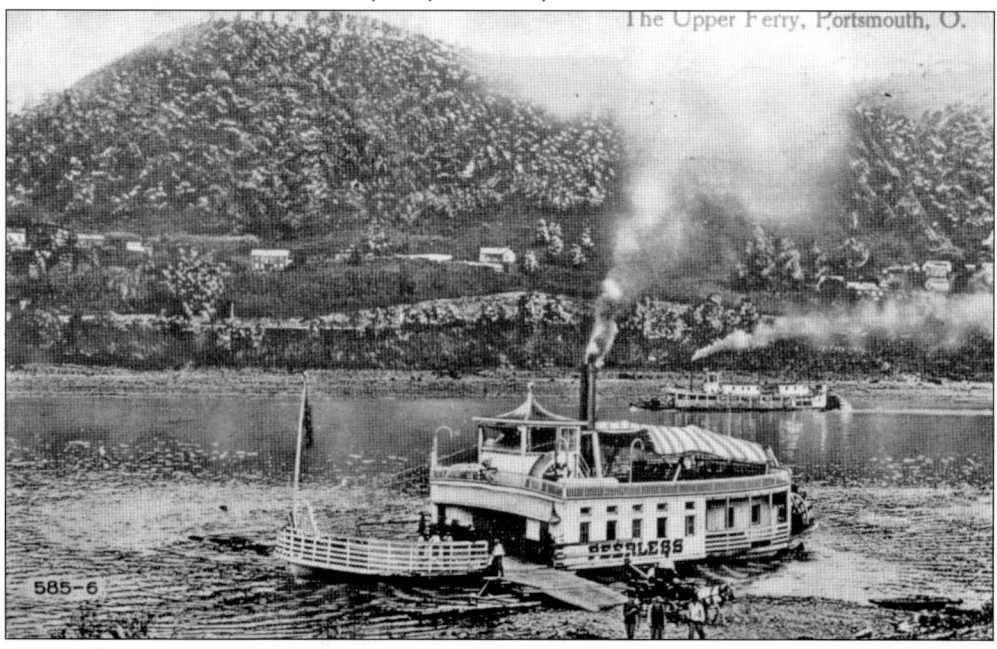

The *Peerless* was known as the Upper Ferry in Portsmouth. Constructed in 1910 and operating between South Shore, Kentucky, and the east end of Portsmouth, it was also used on special excursions. It served as a rescue boat for people and livestock during the 1913 flood. The *Peerless* was later sold to various cities and companies before being consumed by fire in Pittsburgh in 1930. (Courtesy Paul O'Neill collection.)

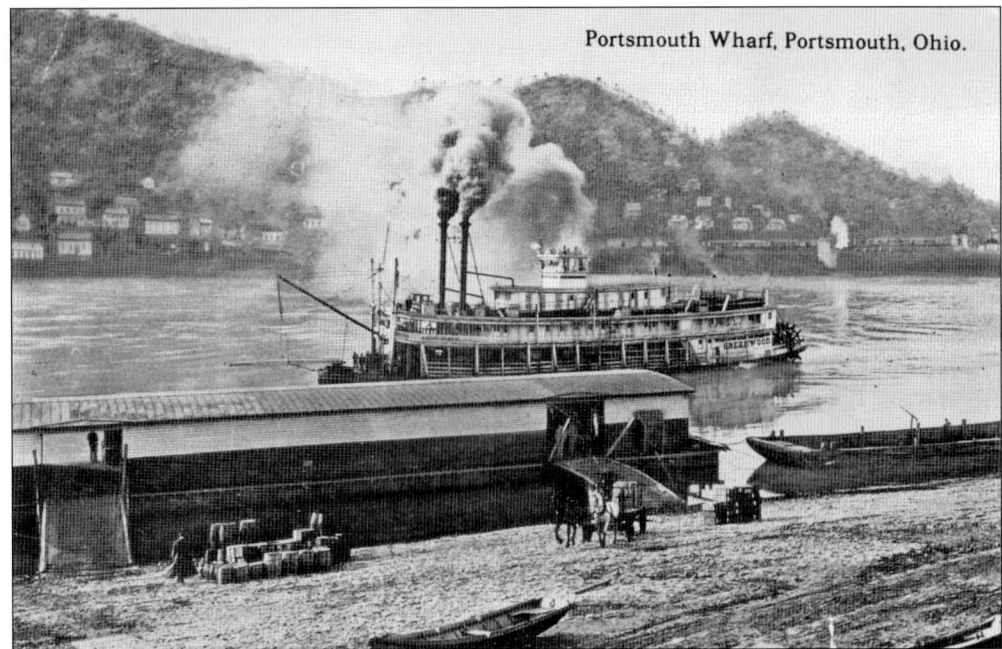

The paddle-wheeled steamboat *Greenwood* makes its way near Court Street landing in this 1914 postcard. Constructed in Parkersburg, West Virginia, in 1898, it was named after co-owner Carrie Greenwood. Operating for many years between Pittsburgh and Cincinnati, the *Greenwood* made thousands of stops while transporting goods to and from Portsmouth. It remained in service until November 1925, when it was destroyed in a collision with another boat in Cincinnati.

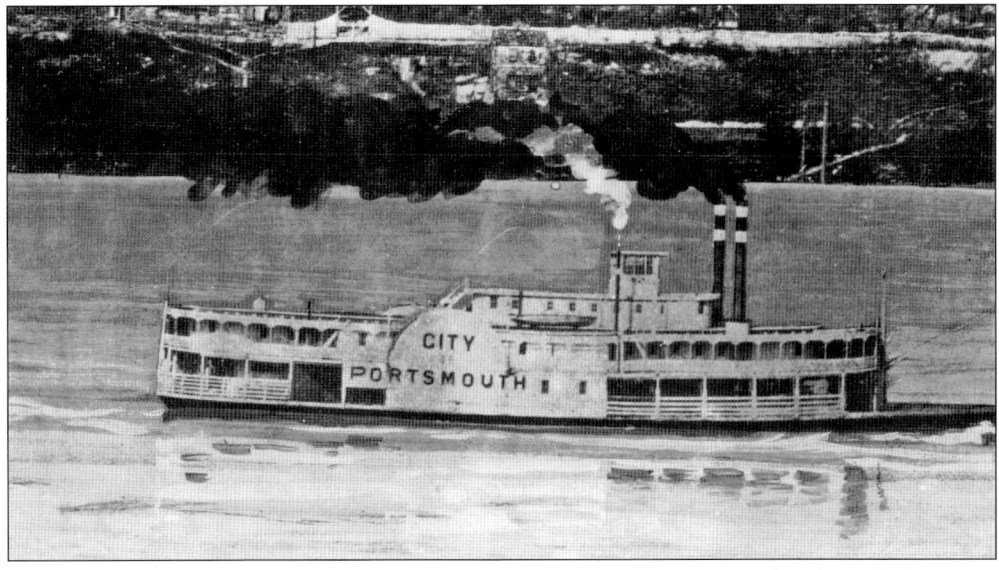

The *City of Portsmouth*, constructed at Cincinnati in 1873, carried mail and goods between Portsmouth and Huntington, West Virginia. Built to compete with another steamboat, the successful *Fannie Dugan*, it was funded by Frank Morgan, a former employee on the *Fannie Dugan*. The bitter rivalry lasted only a few months before the *City of Portsmouth* was sold, finishing its days back in Cincinnati. (Courtesy Paul O'Neill collection.)

Four

GOVERNMENT AND PUBLIC SERVICE

The old post office was located on the east side of Chillicothe Street between Sixth and Gallia Streets. Before construction of the building, the site was a mercantile center. The post office operated there from 1891 to 1936 before being relocated to Gay Street. It was razed in 1956 for the construction of the Montgomery Ward department store.

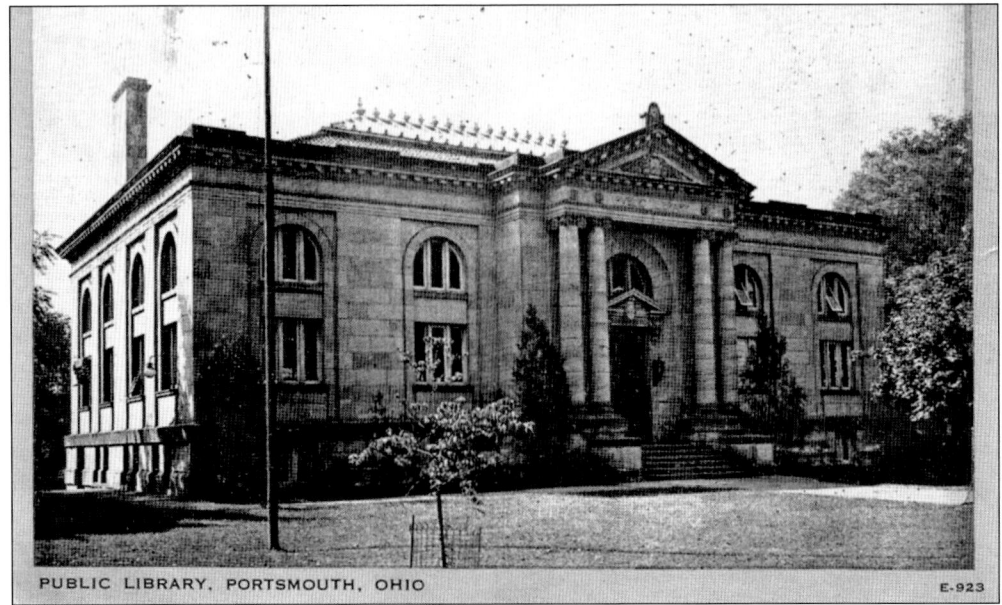

In January 1902, local historian Henry Lorberg sent a formal request to the Andrew Carnegie Foundation for a grant to build a new library. One month later, it was announced that Portsmouth was among 2,800 locations selected to receive funding from Carnegie. The grant was for $50,000. Following a committee's findings that 1220 Gallia Street would be a suitable location, construction on the distinctive building began. The exterior stone, native to the Portsmouth area, was sawed and cut with precision directly at the site. The interior contains massive columns of scagliola marble and cathedral glass for the ceiling's huge dome. Improvements have included the introduction of the bookmobile in 1938, a massive remodeling in 1970, and the expansion of branch libraries countywide.

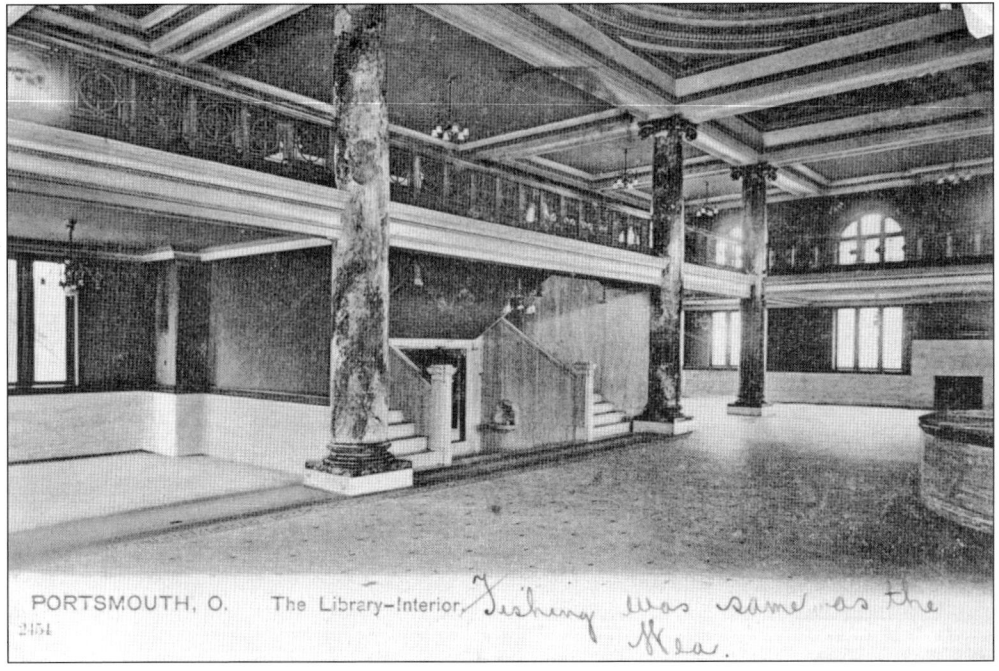

Opening on August 13, 1893, Portsmouth Fire Department Station No. 2 was located at Gallia and Lincoln Streets. It was one of three fire stations within the city. It replaced the days of rival volunteer companies racing to a fire scene, which often ended in violence. The building served its purpose until April 1978, when operations were relocated to the new Central Fire Station. The structure remains standing today. (Courtesy Bill Glockner collection.)

After Ohio earned statehood in 1803, law enforcement in Portsmouth was supervised by the Scioto County sheriff. When the town was incorporated in 1815, William Swords was appointed town marshal, a prelude to the Portsmouth Police Department. In the years since, hundreds of dedicated men and women have served the town, including Lt. Albert Bailey, seen here on his motorcycle near Greenlawn Cemetery in November 1942. (Courtesy Bill Glockner collection.)

For nearly a century, this was the Scioto County Courthouse. Constructed on the northeast corner of Sixth and Court Streets in 1837, it replaced the county's original two-story brick courthouse that was located near Second and Market Streets. Under the supervision of Gen. William Kendall, it was built at a cost of $12,650. In 1927, the current courthouse was completed directly to the east of this structure, which was then razed. The site was later used as a parking lot for the new courthouse. The house visible behind the courthouse was for many years used as the Scioto County jail, until the mid-1920s.

THE SCIOTO COUNTY COURT HOUSE

The present-day Scioto County Courthouse was completed in April 1927 at a cost of nearly $1 million. Located on Court Street between Sixth and Seventh Streets, it was designed by architect John Adkins of Cincinnati. Measuring 143 feet by 158 feet, the courthouse's construction was led by Taylor and Lynn General Contractors of Portsmouth. Built of Indiana limestone, brick, and reinforced concrete, it was one of the sturdiest structures in the area. It was designated as a fallout shelter during the cold war. Today, the common pleas court, domestic relations court, juvenile court, Scioto County commissioners, and several offices for the everyday operations of Scioto County are housed here.

The new, $400,000 Portsmouth post office was completed in September 1936 and is located on Gay Street between Sixth & Seventh Streets. Just four months after the building opened, the 1937 flood inundated the entire first floor. During the flood, the handling of mail was temporarily housed in the Coca-Cola building on Scioto Trail. The structure survives today and is one of the most popular places in Portsmouth.

The Portsmouth Municipal Building was constructed in 1934 at a cost of $102,000. Located on Second Street between Chillicothe and Washington Streets, it was funded by the federal government to help bring jobs to the area during the Depression. Today, the mayor's office, municipal court, police department, engineering office, city clerk, and several other offices involved in city operations are housed there.

Five

EDUCATION

The home of Judge William Salter was located on Sixth Street, behind the current post office. It was deeded to the school board on July 15, 1867. First used as a residence for the school superintendent, it was converted into a school and became known as the Sixth Street School. Elementary, as well as some high school classes, were held in this building. (Courtesy Bill Glockner collection.)

Located on the southwest corner of Second and Chillicothe Streets, the Second Street School was built in 1850. The 12-room school cost $7,184 to build. The structure was torn down in 1917 and replaced by the Massie School. The cornerstone of the Second Street School is today displayed in the hall of the new Portsmouth Elementary School.

The Fourth Street School was built in 1838 on the northwest corner of Fourth and Court Streets. Henry Massie, the founder of Portsmouth, donated the lots on which the school would be built. The cost of construction was $5,450. The cornerstone of the Fourth Street School is displayed in the hall of the new Portsmouth Junior/Senior High School.

The Eleventh Street School opened for classes on September 1, 1876. Located on the southwest corner of Eleventh and John Streets, the property was purchased for $2,500, and the cost to erect the building was $8,067. The school could comfortably accommodate 350 students. In 1926, it was replaced with a more modern structure, Washington School.

The Bond Street School was built on the northwest corner of Fourth and Bond Streets at a cost of $9,117. The 12-room school served elementary students from 1906 to 1939. It was leased to the board of health in 1940 and housed the city's ration board. In 1947, the building was a warehouse for Lewis Furniture Company until it was razed in 1948.

Portsmouth, O.

CAMPBELL AVENUE SCHOOL.

The Campbell Avenue School was located between Sixth and Seventh Streets near Campbell Avenue. Construction on the eight-room schoolhouse began in 1899, and it was finished in 1900 at a cost of $11,425. A four-room addition was built in 1909. Portable units were later added on the grounds. Wilson Elementary School replaced Campbell Avenue School in 1927.

The Davis High School, Portsmouth, Ohio. Photo by Cook

Davis High School, occupying the converted residence of George Davis, was located at Gallia and Waller Streets. It was purchased by the school board in 1897 for $9,999, and an extension was soon built at a cost of $18,000. As many as 230 students could be accommodated, and classes were held from 1902 to 1910. The structure was torn down to make way for the new high school, built in 1912.

The 13-room Garfield Elementary School was built in 1915 at the corner of Gallia Street and Mabert Road. The 2.4 acres were purchased for $18,000, and the structure cost $90,000 to construct. It held about 500 students, but this soon proved inadequate. In 1919, a pair of four-room additions were built on each end of the building, achieving a total of 21 rooms. A new gymnasium was added in 1957.

U.S. Grant School was built in 1930 on the corner of Fourth and Union Streets. It replaced the old Union Street School, which was destroyed by fire in 1929. Grant was built at a cost of $316,000. The building, made of steel, brick, and marble, was completely fireproof. At the time, Grant had the largest gymnasium in the county. The building was razed in 2004.

HIGH SCHOOL, PORTSMOUTH, OHIO.

The first high school building was erected on the front lot of Judge William Salter's property, at Gallia and Findlay Streets, in 1871 at a cost of $10,215. Students first occupied the building in January 1872 and continued using it for the next 30 years. This was the first building dedicated exclusively to high school classes. Prior to this, high school girls were taught at the Fourth Street School and the boys at the Second Street School. The two-story building faced Gallia Street. Prior to the construction of the high school, classes were taught in the Sixth Street School at Judge Salter's former home. The Portsmouth High School class of 1902 was the last to graduate from the building at Gallia and Findlay Streets. That year, the George Davis mansion on Gallia and Waller Streets was purchased and remodeled as a high school. The school board sold the Gallia and Findlay high school property on October 24, 1903, for $13,000.

PORTSMOUTH HIGH SCHOOL, PORTSMOUTH, OHIO

Portsmouth High School was constructed in 1912 at a cost of $315,000. Located on the northwest corner of Gallia and Waller Streets, it replaced the former Davis High School on the same site. A wing was added to the Waller Street side of the building in 1921 at a cost of $271,000, which, when completed, provided a total of 53 classrooms. A vocational training building was constructed next to the high school in 1941, and a new gymnasium and physical education unit were added to the rear of the structure in 1963. The gym featured a special floating floor, designed and built by a unique construction technique to dampen sound and vibrations. The school was closed in 2006, and students transitioned into the new, modern Portsmouth Junior High and Senior High School that year. Portsmouth High School, with the exception of the gymnasium, was razed in 2007.

Cook Photo. Wesley P. Ridenour, Architect

The Warren G. Harding School, Portsmouth, Ohio

Harding Elementary School was located on the corner of Harding and Buckley Avenues. Work began on the two-story school in October 1929 and was completed in 1930 at an approximate cost of $177,000. The building could accommodate 640 students, ranging from first through sixth grade. The gymnasium could seat 600. An addition built in 1950 included a modern science laboratory.

The Highland School, Portsmouth, Ohio.

The old Highland School was built in a cornfield across from Mound Park on Hutchins Street. It was constructed as twin buildings five years apart. The northern half was erected in 1902 at a cost of $21,691. The southern half was built at a cost of $33,300 in 1907. In 1956, the building was razed after the new Highland School was built on the nearby playground site.

THE JOHN LINDSAY SCHOOL. Cook-Photo W. P. Ridenour, Architect PORTSMOUTH, O.

Named after John Lindsay, a pioneer who settled in the area in 1796, the Lindsay School was located on State Route 140 near the intersection of US Route 52. It was an eight-room elementary school with a gymnasium. The Portsmouth City School Board purchased the land in 1926 for $4,000, and the school was constructed in 1928 at a cost of $67,860.

Lincoln Elementary School was located on the northwest corner of Kinneys Lane and Waller Street. The 10-room school was completed in 1914 at a cost of $50,000. Additions were completed in 1922, providing a total of 18 rooms. Due to overcrowding at Washington School, Lincoln became Portsmouth's first integrated elementary school in 1953. A new gymnasium was completed on the east end of the building in 1957.

The Little Red School was built prior to the Civil War just east of the Railroad YMCA building on Gallia Street. After being abandoned, it was sold and moved to Eighth Street and Kendall Avenue, becoming the Earlytown School. After 1905 students were transferred to the Campbell Avenue School, and the Earlytown property was purchased by the Norfolk & Western Railway.

Massie Hall was located on the southwest corner of what was originally Second and Bond Streets. It was constructed in 1966 for Ohio University as its new Portsmouth branch, and remained in that role until 1975, when it merged with Scioto Technical College. In 1977, it became a part of Shawnee State Community College, which in 1986 was renamed Shawnee State University.

Massie School, located on the southwest corner of Second and Chillicothe Streets, was named in honor of Portsmouth's founding father. Construction began in 1917 and was completed a year later at a total cost of $94,551. Replacing the Second Street School that was razed in 1917, it served for four decades until closing in 1958. The building later became Griffin Hall for Shawnee State until it was razed in 2003.

McKinley School, completed in 1917, was located on the corner of Kinneys Lane and Baird Avenue. A 1957 addition, with gymnasium and classrooms, provided three times as much space as the original building. In 1958, it became a junior high school for grades seven through nine, and by 1971 it had become a middle school. From 2000 until it closed in 2006, it housed grades four through six.

Devoss & Donaldson, Architects

The North Moreland (Munn's Run) School, Portsmouth, Ohio. Cook Photo

The North Moreland School was built in 1925 at the intersection of Pleasant Avenue and State Route 139. Initially containing only eight classrooms, a gymnasium and cafeteria were added in 1957. The building was closed in 1982 because of steadily declining enrollment, and it was sold in 1984 to an Apostolic church for $60,000.

Ohio's State Flower—The Scarlet Carnation

Cook Photo

The Roosevelt School, Portsmouth, Ohio

Roosevelt School was located on Coles Boulevard and opened for classes in 1930. The building replaced two framed portable structures that were located at Coles Boulevard and Cedar Street. In 1956, four new classrooms and a gymnasium were added. The building was closed in 2006, and students were moved into the new Portsmouth Elementary School that same year. Roosevelt School was razed in 2007.

St. Mary's School was located on the north side of Fifth Street, between Court and Market Streets. The foundation was laid in 1899, and the building saw its first four-year high school graduates in 1921. It was torn down a few years after Notre Dame High School opened in 1953. (Courtesy Bill Glockner collection.)

The Union Street School was located on the northwest corner of Fourth and Union Streets. The 16-room schoolhouse was completed on December 26, 1877, at a cost of $25,357. The building went through a remodeling phase in 1910. On January 8, 1929, fire destroyed the school, as near-zero-degree temperatures hampered efforts to save it. It was replaced by the U.S. Grant School, which was constructed the following year.

St. Mary's School

The Union Street School, Portsmouth, Ohio.

THE WASHINGTON SCHOOL, PORTSMOUTH, OHIO

Washington School was located on Eleventh Street near John Street. It was built in 1926 as an addition to the existing Eleventh Street School. It was renamed at that time in honor of the well-known educator Booker T. Washington. The original section of the former Eleventh Street School was razed in 1955. In 1990, the property was purchased by Portsmouth Inner City Development and converted into 20 apartments.

The Woodrow Wilson School, Portsmouth, Ohio. Cook Photo.

The Woodrow Wilson School was constructed in 1927 on Campbell Avenue, between Sixth and Seventh Streets. It replaced the old Campbell Avenue School located on the same site. The new 24-room facility was the first elementary school in Portsmouth to have a gymnasium. The building was closed in 2006, and students were moved into the new Portsmouth Elementary School that same year. Wilson School was razed in 2007.

Six

FLOODS

Men in rowboats examine the damage to Anderson's Department Store at Third and Chillicothe Streets during the 1913 flood. Despite earlier assurances by weather forecasters that Portsmouth would likely be spared, continued heavy rains upstream caused both the Scioto and Ohio Rivers to unexpectedly reach flood stage at nearly the same place at the same time. (Courtesy Paul O'Neill collection.)

Looking west on Gallia Street toward Chillicothe Street during the March 1913 flood, the damage inflicted to the Nugget Café, Smith's Bakery, and Columbia Theater, as well as neighboring banks and other businesses, is clearly evident. At the height of the flood, 75 percent of the city was affected in some way. Until 1937, this was the worst flood in Portsmouth's history in economic terms. (Courtesy Bill Glockner collection.)

Alex M. Glockner moved his store from Market Street to the corner of Gallia and Gay Streets just months before the March 1913 flood. Specializing in hardware, Glockner began distributing Harley Davidson motorcycles and Chevrolet automobiles from this building, making it one of the first Chevy dealerships in the United States. The business survived the flood and grew multiple times in the following years. (Courtesy Bill Glockner collection.)

With shocked observers on shore, two men and a boy in a rowboat survey the area where the Second Street Bridge had been located just hours before. Following two days of heavy rains throughout Ohio, a torrent of water estimated at 15 feet high rushed down the already-swollen Scioto River in the overnight hours of March 28, 1913, damaging or destroying everything in its path. (Courtesy Bill Glockner collection.)

In this photograph, two Portsmouth Public Service streetcars sit stranded on the corner of Ninth and Offnere Streets at the height of the 1913 flood. Thoroughly unprepared for the flood, due largely to the frequently inaccurate weather forecasting at the time, Portsmouth suffered from the extraordinarily rapid rise of both the Scioto and Ohio Rivers. (Courtesy Bill Glockner collection.)

The normally bustling retail center of Market Street sits practically lifeless, totally surrounded by floodwaters in March 1913. The Washington Hotel, visible in the background, received extensive damage to its luxurious first-floor lobby, while other businesses shown here suffered widespread losses. Most of the businesses, including the hotel, were able to recover after the flood and enjoyed success in the years that followed. (Courtesy Paul O'Neill collection.)

Looking eastward at Sciotoville in March 1913, the magnitude of damage from the flooded Ohio River is apparent. The mighty Ohio rose an unprecedented 35 feet in a 24-hour span due to constant heavy rains in the Ohio Valley. Considered the most catastrophic weather event in Ohio history, the flood resulted in the deaths of 467 people statewide. Mercifully, no fatalities were recorded in the Portsmouth area. (Courtesy Paul O'Neill collection.)

Residents stand helpless on the Grant Bridge as the Ohio River again overpowers barriers and enters their city in January 1937. A bizarre series of weather events combined to produce what is considered the worst natural disaster in the history of Portsmouth. Reaching record heights, the river flowed more than 12 feet over a recently completed floodwall that had earlier been termed flood-proof.

The unimaginable cleanup begins in downtown Portsmouth following the 1937 flood, as seen in this photograph looking north on Chillicothe Street. While most of the homes and nearly all of the businesses in Portsmouth were heavily damaged or destroyed, citizens banded together to rebuild their town. In the months and years that followed, the flood receded into memory as the city grew larger and more prosperous than ever before.

Two men examine just one of the 620 homes destroyed by the 1937 flood in Portsmouth. As bad as the property damage was, the tragic death of one brave person was even worse. On January 25, Bessie Tomlin was riding in a rescue boat with six other persons when it capsized near Tenth and Waller Streets at the height of the flood. In several feet of water, Tomlin was unwavering in holding her 18-month-old daughter over her head as she herself was being swept under by the raging floodwaters. Portsmouth Fire Department lieutenant Walter Chick, who was in the same boat and was also thrown overboard, grabbed the child almost the same instant that Tomlin went under the water. Chick was able to keep the child above the water until another rescue boat arrived. Tomlin's body was found a short time later. Out of the worst natural disaster to strike Portsmouth, two heroes emerged who provide inspiration to many today.

Seven
Churches

Kendall Avenue Baptist Church originated in 1904 in an abandoned schoolhouse at Ninth Street and Kendall Avenue in Earlytown. The property was acquired by the Norfolk & Western Railway, and a new church was constructed at Robinson Avenue and Young Street in 1924. The name was changed to Central Baptist Church, and the structure remained until a fire in 1961. A new church on Highland Avenue opened in 1964. (Courtesy Paul O'Neill collection.)

ALLEN CHAPEL, PORTSMOUTH, OHIO

Allen Chapel African Methodist Episcopal Church held services in Wheeler's Academy on Fourth and Market Streets until the congregation purchased a small frame building on Fifth Street. In 1868, Allen Chapel moved to Seventh Street, east of Chillicothe Street. In 1921, a service of leave was held, followed by a march to the new location (shown here) at Twelfth and Waller Streets. (Courtesy Paul O'Neill collection.)

The Franklin Ave. M. E. Church, Portsmouth, O.

The Franklin Avenue United Methodist Church was constructed in 1917, following the continued growth of German-speaking members of the Methodist faith in the area. Located on the southeast corner of Franklin Avenue and Logan Street, it replaced the German Methodist Episcopal Church at Fourth and Washington Streets. In 2001, Franklin Avenue United Methodist Church decided to merge with three other churches, forming Cornerstone United Methodist Church.

The German Presbyterian Church, Portsmouth, O.

The German Presbyterian Church originated in 1866 and opened its first building (above) in 1869 on the corner of Seventh and Chillicothe Streets. Prior to this, services were held in the old Court House and in Connelly Hall. In 1908, services in German ended, and the church was renamed Central Presbyterian Church in 1909. In 1925, it was razed to make way for the Grand Hotel. Services were then held in the United Brethren Church at Seventh and Gay Streets until a new building (below), at Twenty-third and Waller Streets, was completed in 1927. During the 1937 flood, the church was used as a refuge for those who found themselves displaced. Hundreds were fed and clothed while waiting for the water to recede. Central Presbyterian was the only church able to hold services during this time. Central Presbyterian was later acquired by Calvary Baptist Church.

The Central Presbyterian Church, Portsmouth, Ohio

Christian Church (East End), Portsmouth, O.

Central Church of Christ originated in the Lawson Heights School as a mission project sponsored by First Christian Church. It later moved to an abandoned school building on Vinton Avenue. A small brick chapel (shown here) was built on the northwest corner of Grandview and Robinson Avenues in 1905. The congregation requested to become self-supporting, and in 1907, it became known as the Grandview Avenue Church of Christ. (Courtesy Paul O'Neill collection.)

THE GERMAN EVANGELICAL CHURCH

The Evangelical United Church of Christ began when two groups of German immigrants joined for worship in the west end of the city. In 1852, a church was built on Fifth Street and dedicated as German Evangelical Church. A new structure (shown here) was built across the street and dedicated in 1887. After a merger in 1956 with Congregational Christian Churches, the church was renamed Evangelical United Church of Christ.

The history of Bigelow Methodist Church originates in the days of circuit riders, who preached at the Old Stone House in West Portsmouth. In 1820, the church purchased Jacob Wheeler's Academy, and this became the congregation's first real home. Due to continued growth, a new building was erected on Second Street between Market and Court Streets in 1834. As the community continued to grow, another building was needed. A new location was selected at Fifth and Washington Streets in 1858. In 1859, the church was partially destroyed by fire. Flames struck again in 1867, leaving nothing but bare walls. It was over two years before the church was reoccupied. Floodwaters entered the church in 1884, 1913, and, worst of all, in 1937, when the organ, pews, and many other pieces of property became a total loss. (Courtesy Bill Glockner collection.)

Pleasant Green Baptist Church was organized in February 1864 by Rev. B. Harper. He organized the baptized believers, and they met in their houses. These parishioners built a place of worship on the corner of Tenth and Findlay Streets and dedicated the church in 1865. In later years, the lot at 1421 Waller Street (shown here) was purchased, and a new church was built.

Manley Church, built in 1892 at Eleventh and Clay Streets, served the East End. The organ was pumped by foot, oil lamps were used for lighting, and two stoves warmed the congregation. A full basement and four rooms were added by 1912 to accommodate church growth. It was razed in November 1955 and replaced by the east branch of National Bank. (Courtesy Paul O'Neill collection.)

All Saints Episcopal Church was organized on June 23, 1819. Among the 23 persons signing the Articles of Association were Aaron Kinney, Thomas Waller, John Smith, and Samuel Gunn. Infrequent services were held at the old Market Street Court House and, later, at the Commercial Bank on Second Street. The congregation's first building was dedicated in 1833 on the site where the Samuel Gunn Parish Hall stands. In 1850, the second church, a Gothic Revival structure, was built on Fourth Street. Gas lights were added in 1855, making it the first public building in Portsmouth to have them. Rev. Erastus Burr (inset above) was rector for 35 years, during the church's most formative years, from 1838 to 1873. Fire destroyed the interior of the church in 1893, but it was rebuilt six months later. (Inset courtesy Bill Glockner collection.)

In 1853, the First Christian Church was organized at Fifth and Court Streets. In 1859, the congregation moved opposite Tracy Park on Chillicothe Street. The church was relocated to Third and Gay Streets in 1876. It was razed in 1974 due to the widening of Gay Street, and services were held in the Jewish Temple and Evangelical United Church of Christ until the new church on Third Street was constructed.

Portsmouth First Church of the Nazarene was organized in 1920 with 19 charter members, who met in members' homes until securing a tent on Third Street. In 1933, the congregants moved to the tabernacle on the northwest corner of Seventh and Broadway Streets. When the congregation moved to its present location at Third and Brown Streets in 1937, services were held in the basement until the remainder of the church was completed in 1947.

The United Brethren Church was organized with 16 members in 1865, with services held in Connelly Hall. A building in the Gothic style was erected on the northeast corner of Seventh and Gay Streets in 1867. Services were held in German until 1897, when, due to a decrease in members, the church changed to English-language services. In 1918, the congregation moved across Gay Street when a new building was completed. The name of the church was changed to First Evangelical United Brethren in 1946, and then to The United Brethren in 1968, as a result of mergers. It was known as the First United Methodist Church when it merged with other local churches to create Cornerstone United Methodist. The building and contents were auctioned off in 2003 before the structure was razed for a parking lot for Kroger. (Courtesy Paul O'Neill collection.)

In 1853, when Bigelow's congregation overwhelmed its facility, a new church, Spencer Chapel, was built at Seventh and Chillicothe Streets. This was later sold to the African Methodist Episcopal Church, and a new building was constructed at Sixth and Chillicothe Streets. Named Sixth Street Methodist Church, by 1906, downtown businesses had engulfed the church, so another one was built at Gallia and Offnere Streets. The name was changed to Trinity United Methodist Church. In 1983, Trinity and Bigelow were once again joined as one church. With decreasing membership and increased expenses related to maintaining the old structures, several Methodist churches merged and became Cornerstone United Methodist. The bell tower features the refurbished bells from the Franklin Avenue United Methodist Church, and cornerstones from each merging church are displayed. (Courtesy Paul O'Neill collection.)

Holy Redeemer's history began in 1844 with the Church of the Nativity at Third and Madison Streets. In 1852, the parish was divided into two language congregations. The German-speaking Catholics developed St. Mary's, while the English-speaking parish used the Presbyterian Church on Second Street. Completed in 1853, the first Holy Redeemer Church opened on Sixth Street, but it soon outgrew its facilities. The priest developed a financial plan whereby each wage-earning member would donate a penny a day for a future building. When that building was destroyed by fire in 1905, the First Evangelical Church lent its old building until 1908, when the new Holy Redeemer Church (shown above and below) was ready. Bells were installed in 1914, and Holy Redeemer School was completed 1917. (Both courtesy Paul O'Neill collection.)

Second Presbyterian Church separated from First Presbyterian Church due to the need for expansion. The dedication of the new church was held in February 1875 at Eighth and Waller Streets. Fire totally destroyed the contents and severely damaged the auditorium 20 years later. The following year, a mysterious explosion occurred, blowing out many of the windows. As the congregation continued to grow, expansion was necessary. A temporary tabernacle was used while a new building was constructed. In 1933, fire struck again, leaving only the wall, bell tower, and a few of the priceless windows. The church was rebuilt once again and dedicated in 1935. The exquisite stained-glass windows seen today have over 182 different colors and were imported from various countries. (Left, courtesy Paul O'Neill collection.)

First Christian Church, affectionately known as "Little Gem," originated in 1917 on property purchased for $1 from New Boston developer Levi York. Due to congregational growth, the building was razed and construction of a new church began in 1927 on the same site. Services were held in Oak Street School until the building was completed. After the arrival of Rev. Thomas Kerr, the church was renamed Cedar Street Church of Christ in Christian Union after joining the denomination in 1937. Since the 1950s, the church has taken on a different building project each decade, with the sanctuary being enlarged, updated, and modernized to meet the needs of the growing congregation and community. A fellowship hall was built in the 1980s, and in the 1990s, the sanctuary was expanded again. The parsonage was renovated into the church annex, with office and meeting space. The latest addition has been the Upper Room youth facility, utilized for teen ministry. Rev. Roy Heimbach and grandson Gary Heimbach are among the 12 pastors who have led the church since 1930.

On the last Sunday of 1910, Billy Sunday held a crusade in a tabernacle at Eighth and Lincoln Streets. This revival lasted six weeks, with a total of 5,200 converts promising to take a strong stand against alcohol, gambling, and dancing. Billy Sunday (1862–1935) was a professional baseball player from 1883 to 1891 in Chicago, Pittsburgh, and Philadelphia. While in Chicago, he was converted by a street preacher. He left a $5,000-a-year salary as a baseball player for an $84-a-month ministry position with the previously evangelistic YMCA. Shortly after deciding to work with the YMCA, Sunday was offered a $5,000 baseball contract for one season by Cincinnati, but after much thought, he decided to turn it down. This dynamic "baseball evangelist" conducted approximately 300 crusades in the 39 years of his ministry, preaching to over 100 million people. It was a number that went unmatched until the ministry of evangelist Billy Graham. (Courtesy Paul O'Neill collection.)

Eight
ENTERTAINMENT AND RECREATION

A crowd enjoys the facilities of York Park in this 1915 postcard. Located along the Ohio River, southwest of Front and Chillicothe Streets, the property was previously the location of a mill owned by businessman Levi York. When that facility burned down and relocated to New Boston, York donated the land to the city for the sole purpose of constructing a park to be enjoyed by both young and old.

Opening on September 24, 1924, the Valley View Country Club, located northwest of Portsmouth, was designed by Donald Ross, architect of golf courses used on the PGA tour. The property was originally the Lucas farmstead, dating to the early 1800s. The golf course was sold and renamed Elks Country Club in 1941. A remnant of the Lucas farm still survives; the family cemetery is located between the first and second holes.

Constructed in 1929 at a cost of $93,000, Dreamland Pool on Kendall Avenue was arguably the most popular outdoor recreational facility in Portsmouth's history. Comprising over three acres, it included one of the largest outdoor swimming pools in the nation. Countless thousands enjoyed the warm-weather activities over the park's six decades of operation. Falling into disrepair and amid much public protest, Dreamland closed in 1993. (Courtesy Bill Glockner collection.)

Between 100 B.C. and 600 A.D., the Hopewell Indians created numerous ceremonial mounds in Southern Ohio and Northern Kentucky. A horseshoe-shaped mound that survived modern development is located near Grant and Seventeenth Streets on property once owned by Simon Labold. In 1918, Labold donated his nine acres of land to the city for use as a recreation area. The mound survives today in the appropriately named Mound Park.

Tracy Park was donated to the city in 1853 by Francis Campbell, who requested that the three-acre park be named after his friend, Portsmouth attorney Samuel Tracy. The 40-foot Soldiers Monument was dedicated in 1879 in honor of six local Union soldiers killed in the first days of the Civil War. John Barnes, the first of the six killed, is portrayed on top. (Courtesy Bill Glockner collection.)

The infamous roller coaster at Millbrook Park was installed in April 1910 at a cost of $15,000. Considered a daring thrill ride, it stood 60 feet tall with more than one-half mile of tracks. Lillian Addis and Ada Frick were among the first to ride the coaster, which took 90 seconds to complete. Sadly, it was destroyed by the 1913 flood and never rebuilt. (Courtesy Bill Glockner collection.)

Although work was started on Millbrook Park in 1899, it was not completed until 1910. From the top of the roller coaster, the rider could view the entire 85.4-acre grounds. The park included a baseball field, bowling alley, skating rink, and a dance floor as well as amusement rides, picnic areas, tennis courts, boat rides, and a large theater call the Casino. (Courtesy Bill Glockner collection.)

The original Millbrook baseball park was built in 1906 with bleachers along both foul lines. In 1908, a grandstand was added that accommodated 1,100 people. High school and professional teams used this field for games and practice. The New York Giants, Chicago Cubs, and Cincinnati Reds all played exhibition games here. Other sports such as football, wrestling, and prize fighting also took place here. (Courtesy Bill Glockner collection.)

The Millbrook Casino was located in the 4200 block of Rhodes Avenue in New Boston, approximately where the Cornett building was later located. Those coming to the park were entertained with plays, concerts, films, and even off-Broadway productions. The two-story building, erected in 1905, could seat 500 people. The popular River City Band gave performances every Sunday throughout the summer. (Courtesy Bill Glockner collection.)

The Waiting Station, Millbrook Park, Portsmouth, O.

According to the 1909 opening-day records, over 8,000 people rode the trolley to Millbrook Park, as "Streetcar Parties" had become quite popular at this time. The Waiting Station was located where the current Frank's Place is. Those from Sciotoville and Portsmouth would make connections here. This was the second station site, as officials wanted to operate the busy tracks outside the actual park area.

The largest merry-go-round assembled in the United States in 1905 was purchased that year for Millbrook Park at a cost of $3,900. The ride had a seating capacity of approximately 50 people, including seats for those not wanting to ride the fancy painted animals. The song "Goodbye My Blue Bell" was the popular tune of the day. (Courtesy Bill Glockner collection.)

Universal Stadium opened on September 14, 1930, when the National Football League's Portsmouth Spartans defeated the Newark Tornados 13-6. The next home contest featured one of the first night games in NFL history. Financed by local businessmen, Portsmouth had recently been granted an NFL franchise, joining 10 other teams, including the Green Bay Packers and the New York Giants. In 1932, the Spartans played the Bears in Chicago for the championship after ending the season in a tie. While on the losing end of a 9-0 clash, it was the first playoff game in NFL history. A disappointing record and the effects of the Great Depression caught up with the Spartans the following year. The team was sold, relocated to Detroit, and renamed the Detroit Lions. As a final tribute, Universal Stadium was renamed Spartan Stadium in 1970. (Courtesy Paul O'Neill collection.)

Immediately east of Universal Stadium was Riverside Park, constructed in 1935 for the Portsmouth Red Birds professional baseball team. After that team relocated in 1939, it was used by Portsmouth High School, the Del Rice youth league, and American Legion Post 23, among many others. After Scioto County native Branch Rickey passed away, the park was renamed in his honor on July 14, 1966. (Courtesy Bill Glockner collection.)

Beginning in 1913, Portsmouth joined other regional towns in hosting an annual four-day corn carnival, at which area farmers and merchants could sell their goods. One of several legends says that Portsmouth sponsors decided to change the first letter of each word in the festival's name, as seen in this image, to make it stand out from the others. Although highly popular and successful, the event was terminated with the onset of World War I.

Sarah Francis Frost was born in England on August 17, 1865. When her parents moved to Portsmouth in 1873, the seven-year-old self-described tomboy was already attracted to the acting profession. Residing for a brief time in a Second Street house that survives today, Frost skyrocketed to fame in New York City and became a legend on the Shakespearean stage under the name Julia Marlowe. (Courtesy Bill Glockner collection.)

Seen here in 1922, the River City Band was organized in Portsmouth in 1898 and performed thousands of times over the next 30 years. Ranging from 20 to 30 members, the band played multiple locations throughout the region, including the Ohio State Fair. Locally, it performed at circuses, business grand openings, special concerts at both Tracy Park and Millbrook Park, and nearly every holiday parade that Portsmouth hosted.

The Grand Opera House and Hotel was constructed in 1895 and located at Chillicothe and Fourth Streets. Considered the finest entertainment facility in Portsmouth at the time, it unfortunately had a short life. Gutted by fire in September 1914, it never reopened. The structure was rebuilt and remodeled into the popular S.S. Kresge Store, which stood for many years. The building is currently occupied by the Diamond Gem Pawn Shop.

Baseman's Auditorium, located on the southwest corner of Ninth and Chillicothe Streets, saw a wide variety of businesses in its history. Constructed around 1905, the arch-roofed structure has at different times contained a bowling alley, a dance hall, WPAY Radioland, a roller-skating rink, a Ford automobile dealership, and, finally, Classic Lanes Bowling. The building was razed in 1975 for the construction of Southern Hills Hospital.

Constructed as the Sixth Street Methodist Church at Sixth and Chillicothe Streets, the congregation felt crowded by the business growth in this area and relocated to Gallia and Offnere Streets in 1909. The prized piece of real estate left behind was quickly acquired and remodeled as the Playhouse, which featured billiards, bowling, a cigar store, the Elks Club, and, later, the Majestic Theater. (Courtesy Bill Glockner collection.)

The Eastland Theater was located at 1804 Eleventh Street and opened in February 1920. Highly publicized as being the first area theater that featured separate men's and women's restroom facilities, the popular facility remained in business until 1955. The building was vacant until 1963, when it was purchased by Luther Transfer Moving Company. (Courtesy Bill Glockner collection.)

The Columbia Theater on Gallia Street opened on November 21, 1910, and made an immediate impression with its 5¢ admission price. In 1928, the first talking motion picture shown in the area was exhibited here. With a peak seating capacity of 1,000, the Columbia survived everything from floods to economic depressions. A catastrophic fire in 2007 completely destroyed the interior, leaving only the exterior walls intact. (Courtesy Bill Glockner collection.)

The Garden Theater was located at 718 Chillicothe Street and opened in 1925. Featuring Portsmouth native Roy Rogers performing early in his remarkable career, it was one of the nearly two dozen stage and screen theaters in the Portsmouth area over the years. Closing in 1958, the building was later occupied by a sign business until it was razed and replaced with Kroger's Supermarket. (Courtesy Bill Glockner collection.)

The LaRoy Theater, located on the corner of Gallia and Gay Streets, opened on January 11, 1926. It featured a young entertainer named Milton Berle as one of the vaudeville opening acts for the headlined silent movie. Located on the same block as the rival Columbia Theater, it remained in operation until 1973. The building was razed in 1974 for a street-widening project. (Courtesy Bill Glockner collection.)

The first Lyric Theater (two additional theaters later shared that name) was located at 426 Chillicothe Street and opened in 1912. With a seating capacity of 450, its perfect location gave downtown shoppers the opportunity to view either the latest Charlie Chaplin movie or newsreels covering World War I. It was razed in 1924 for the extension of the First National Bank building. (Courtesy Bill Glockner collection.)

Not all Portsmouth theaters were blessed with success. In fact, many closed within their first year of operation. The Orpheum Theater originated at 616 Chillicothe Street around 1912, but relocated a short distance to 835 Gallia Street two years later. The move apparently did not help, as it was sold and renamed the Sun Theater in just a few months. It closed permanently in 1915.

Laws Hollywood Theater, at 820 Gallia Street, opened on September 3, 1925. Managed by George Law, it was constructed in less than six months. With a seating capacity of 600, it featured an entertaining six-piece orchestra that performed during both stage and motion-picture acts. Sold in 1928 and renamed the Lyric, the theater remained in business until it was razed in 1959. (Courtesy Bill Glockner collection.)

Nine
AROUND THE TOWN

The prominent Albert Zoellner Jewelry Store clock on the right indicates it is 9:30 on a typical Portsmouth morning around 1923. While automobiles and streetcars compete for positions at the intersection of Chillicothe and Third Streets, residents on foot take advantage of the numerous businesses downtown. Among them is Anderson's Department Store (left), which in later years became Sears.

The Grand Hotel was located on the northeast corner of Seventh and Chillicothe Streets. It was constructed around 1925 on the former property of the original Central Presbyterian Church. By 1932, it was known as the Lee Hotel. The hotel retained this name until the building was torn down about 1970 for the present municipal parking lot. (Courtesy Bill Glockner collection.)

The extravagant Hotel Portsmouth was located on Front Street facing the Ohio River. For many riverboat passengers in the early 1900s, this was the first indication that they had arrived in Portsmouth, Ohio. Operating for over half a century, the building eventually fell into poor condition. It ultimately went into foreclosure and was sold at a sheriff auction in October 1958. Shortly thereafter, it was razed. (Courtesy Bill Glockner collection.)

The Hotel St. Louis, located at 734 Third Street, was originally constructed as a Welsh church around 1900. By 1906, it had been converted to an economical 25-room hotel, one of several developing in the city at that time. Sold and renamed the Turner Hotel in 1915, it became the Kendrick Hotel in 1939. By 1964, it had changed names again, to the Uptown Hotel. It was known under this name until the 1970s. (Courtesy Paul O'Neill collection.)

At eight stories, the Hurth Hotel was the tallest hotel in Portsmouth, and popular for its views of the city and the surrounding natural scenery. Constructed in 1926, it is located at 222 Chillicothe Street. The hotel was named for its owner, Adolph Hurth. The distinctive lighted sign on the roof could be seen for miles. In 1982, it was converted into apartments for the elderly. It continues in this capacity under the name Hurth Apartments.

The Biggs House, Portsmouth, Ohio

The current Biggs House on Market Street opened on April 18, 1872, following a disastrous fire a few months prior that destroyed the original hotel and several neighboring structures. In its prime, it was known as the finest hotel between Pittsburgh and Cincinnati, featuring the finest rooms and amenities. A barbershop, billiards room, cigar store, clothing store, saddle shop, shoe store, a Western Union telegraph office, and offices to purchase steamboat tickets were all contained within its walls. Among the celebrities who stayed there were Buffalo Bill, Henry Clay, Union general Philip Sheridan, and Presidents William McKinley, Theodore Roosevelt, and William Howard Taft. Rates averaged $2 per day, which included three meals in the formal dining area. By the 1970s, the hotel and its neighbor, Washington House, were purchased by Scioto Memorial Hospital and converted into specialty apartments for the elderly. Following a multi-million-dollar remodeling of both buildings, Biggs House became a part of Olde Market Square in March 1979. (Courtesy Bill Glockner collection.)

THE HOTEL JAMES, 1146-48-50 NINTH STREET, PORTSMOUTH, OHIO

The Hotel James, located at 1146 Ninth Street, was constructed around 1920. It was built primarily using materials from the recently dismantled World War I training facility Camp Sherman, near Chillicothe. Ownership of the hotel soon changed, and it became the Cooper Hotel by the mid-1920s. Featuring low rates, comfortable rooms, and a restaurant that included live music on weekends, it instantly became a blue-collar alternative to the more glamorous hotels downtown. By the 1970s, it had developed into a hotel providing for the homeless and those in need. At 10:00 a.m. on April 15, 1971, a fire quickly spread through the aging structure. All fire personnel from Portsmouth and New Boston responded to the inferno and prevented the blaze from spreading to many nearby buildings. After two and a half hours of fighting the fire, which injured three firefighters, it was brought under control. It was soon determined that all but one of the 26 occupants of the destroyed building were able to escape. Leo Jessing, a laborer from Dayton looking for work in Portsmouth, perished. (Courtesy Paul O'Neill collection.)

The magnificent Washington Hotel, located on Second Street, opened for business on March 14, 1901. Named after the nation's first president, it was financed by a group of businessmen who organized the Portsmouth Hotel Company two years earlier. Raising funds and only working with the most qualified people, the board of directors hired Harrison Albright of Charleston, West Virginia, to design the extravagant hotel. When completed at a cost of $120,000, only the finest managers and staff were hired. Containing all of the amenities of the neighboring Biggs House, the Washington Hotel engaged in stiff competition with its rival for decades. In the 1970s, both were purchased by Scioto Memorial Hospital and converted to housing for senior citizens. Opening in September 1979, it remains today an important part of Olde Market Square. (Below, courtesy Paul O'Neill collection.)

FRANKLIN MOTEL

The Club Franklin (below), located on Route 23 just north of Portsmouth, opened for business on June 8, 1941. The owners and operators, Mr. and Mrs. Frank Vournazos, had been in the restaurant and nightclub business for over 20 years prior to opening the Franklin. With a seating capacity of 170 persons, the club also featured a private banquet room, dance floor, and the new luxury of air-conditioning. Opening night featured music by Mr. Chang and his orchestra, who were national radio stars known for performing dance music. Live entertainment continued for several years. Around 1960, a motel (above) was constructed on the same property to take advantage of the increase in travelers on the recently improved Route 23. While the motel, converted to apartments, slightly outlasted the nightclub, both were closed before 2010. (Courtesy Paul O'Neill collection.)

CLUB FRANKLIN DINING ROOM

The Joseph G. Reed Wholesale Dry Goods Store was located on West Second Street. It was immediately considered the strongest-built structure in Portsmouth. Opening in 1906, the business closed in the early 1930s, and the building was used for temporary offices by the city until the Municipal Building was completed. Standing vacant for the next decade, the structure was heavily looted of anything valuable, including the elevator motors and radiators. Purchased by Virgil Fowler and his three sons in 1946, the building was completely refurbished, and Fowler relocated his well-known photographic studio equipment there from its prior location at 634 Second Street. For many years, the structure, which included Fowler's personal residence on the top floor, was known as the Fowler Building. Everything from group and individual photographs to X-rays were performed here. At the same time, Fowler operated one of the first film-developing shops on Gallia Street. In 1981, the building was purchased and heavily remodeled into 50 apartments for handicapped and senior citizen housing. The Horizon House, as it is known today, continues serving this useful purpose. (Courtesy Paul O'Neill collection.)

Market Square, looking South, Washington Hotel in Center, Portsmouth, Ohio.

With the newly completed Washington Hotel in the background, this section of Market Street was the trade center of Portsmouth for many years. Designed in the early 1800s as an extra-wide thoroughfare, Market Street received its name because this is where local farmers would gather every Saturday. The farmers traded with one another and with area businesses, exchanging meat and produce for most of the supplies needed at their homesteads. In later years, this area became, and remains today, an important retail center in Portsmouth. Some of the notable businesses over the years included Candyland, Hurth Liquors, Schaefer's Grocery, Lantz Drug Store, Count's Bakery, Market Street Hardware, Market Street Café, Hermann's Meat Market, and West End Shoe Mart. A fire in 1978 destroyed a small portion of the neighborhood, which contains some of the longest-standing structures in Portsmouth. A revitalization project began in the 1970s to restore and preserve these historic structures, a worthwhile effort that continues today. (Courtesy Bill Glockner collection.)

THE ARDZLI TEA ROOM
732 Sixth St.,
PORTSMOUTH, O.

The Ardzli Tea Room was located at 732 Sixth Street, within walking distance of the courthouse, post office, and many downtown businesses. Since an urban tearoom drew most of its customers from lunch crowds, its location was of critical importance. Many such establishments were situated close to a city's shopping district. Ardzli was very popular in the 1930s and 1940s, and hosted many women's social club meetings.

A free toy airplane with every $1 purchase was an incentive to shop at Winfield S. Nye's drugstore on the southwest corner of Fourth and Chillicothe Streets. This photograph shows the corner around 1925. Operating there until the building was nearly destroyed by the 1937 flood, the store relocated (ironically two blocks closer to the Ohio River) to the northwest corner of Second and Chillicothe Streets. It closed in 1953.

The Grimes Hotel, located on the southwest corner of Second and Gay Streets, was constructed in the early 1900s. In 1913, the YWCA acquired the building and remained there until 1921, when the building was converted into the Grimes Apartments. The structure remained as an apartment building until it was razed in 1965 during an urban renewal project that became part of Shawnee State University. (Courtesy Bill Glockner collection.)

One of the many family-operated businesses in Portsmouth was Knittel's Bakery, located at 63 West Second Street. In this 1910 photograph, owner Mame Knittel and youngster Ray Lindsey pose for the photographer, whose studio was directly across the street. Among the items displayed in the windows are the newly invented cylindrical Thomas Edison phonograph records. (Courtesy Bill Glockner collection.)

Constructed in 1905, the Portsmouth landmark Turley Building stood on the northeast corner of Second and Chillicothe Streets. Named after its owner, Leslie C. Turley, who was associated with local brick plants and real estate, the building originally contained the First National Bank until it relocated in 1912. Several smaller businesses were able to rent the spacious first floor until a fire in 1924 nearly destroyed the building. Purchased and transformed into Glockner Hardware following the fire, the business remained until after the 1937 flood, when Lewis Furniture acquired it for a warehouse. In 1948, Mr. and Mrs. Nathan Bernstein of Cincinnati bought the building and opened the popular Checker Department Store, which continued until 1973. Custom Carpets and the Brothers Four nightclub occupied the building in the following years, which also included another fire in 1979 that nearly destroyed the building. In the early 1990s, it was purchased by Shawnee State University, which was in the midst of an expansion program. To permit a rerouting of nearby Second Street, the building was razed in March 1992.

The Damarin family came to Portsmouth in 1833 from France, becoming successful businessmen. They purchased a prized piece of real estate on the northwest corner of Second and Court Streets around 1890. In 1892, several neighboring merchants petitioned the government to have the future post office constructed on this property, which would benefit them due to the increase in traffic. It would also make A.M. Damarin a wealthier person. Meanwhile, businessmen "uptown" wanted the new facility in their neighborhood, for the same reasons. The uptown group prevailed when they offered the property to the government at no cost, an offer the west end merchants could not match. Disappointed but content with the results, Damarin constructed a three-story brick building in 1896, which contained a retail business on the first floor and apartments on the upper two. The T.D. Bendure store, seen in this 1909 postcard, featured 12,000 square feet of retail space. Selling dry goods, notions, ladies' dresses, and men's and women's shoes, it employed 20 people. The structure remains standing today, with an antique store occupying the first floor.

GOVERNMENT SQUARE, LOOKING WEST, PORTSMOUTH, OHIO.

The Gallia Street Esplanade began in the late 1800s as a place where local farmers would gather to trade their goods with area merchants in the center of town, similar to what was done on Market Street in earlier years. In these mid-1920s postcards, the area has been renamed Government Square, primarily due to the post office being located nearby. In later years, the area received multiple alterations, with one of the streets being replaced with various displays and pedestrian-related improvements. In August 1959, the area was renamed for Roy Rogers, the "King of the Cowboys," who spent much of his childhood in Scioto County. The ceremony was attended by thousands, including the honoree. Today, the Roy Rogers Esplanade remains the center of downtown Portsmouth.

Government Square, Portsmouth, O.

Portsmouth College of Business.
Central National Bank.

Royal B. & L. Ass'n Co.

The Auditorium (above), which opened for business in June 1921, was located at Gallia and Bond Streets. Featuring a dance hall and the area's first indoor swimming pool, used by the local YWCA, the building was later purchased by the Selby Shoe Company, which installed a bowling alley and used the facility primarily for employee functions. In 1938, the building was acquired by the River City Aerie No. 567 of the Fraternal Order of the Eagles (below), who occupied it for nearly half a century. In 1986, it was acquired by American Legion Post No. 471, which remains the occupant today. (Above, courtesy Paul O'Neill collection.)

An estimated 100,000 individuals are at eternal rest in Greenlawn Cemetery. Established on March 9, 1829, as Evergreen Cemetery, the first sections were purchased to replace the original City Cemetery at Third and Madison Streets, which was a victim of yearly flooding, with the expected gruesome results. Those buried there were relocated to Evergreen, where each section was owned by a church or family who was responsible for its upkeep. By the 1850s, the city began acquiring neighboring properties. A fire in 1871 destroyed all records up to that point, making an exact count and location of some of the early graves almost impossible. The city council voted in 1873 to change the name to Greenlawn Cemetery, and by the 1880s had taken over sole responsibility for its care. In May 1884, a chapel was dedicated. It was listed in the National Register of Historic Places in 1980. (Courtesy Bill Glockner collection.)

In 1862, the Ladies Aid Society was organized in Portsmouth to raise money for the families of Civil War soldiers and to send much-needed supplies to the troops on the battlefield. Following the war, the group disbanded, but soon realized it had leftover funds that needed to be disbursed. That money was used to finance the Civil War Union Soldier Monument at Evergreen (later Greenlawn) Cemetery. The monument was dedicated on May 30, 1869. A few years later, veteran Union captain William Wallace Reilly was selected to design what would be known as Soldiers Circle. Surrounding the existing monument, the circle was dedicated on May 30, 1884. More than 2,300 combat veterans, including 670 from the Civil War, are buried in Greenlawn Cemetery from nearly every conflict from the Revolutionary War to the Vietnam War. (Courtesy Paul O'Neill collection.)

This c. 1928 view, looking north on Chillicothe Street from Second Street, would greet a traveler entering Portsmouth from Kentucky. The recently completed eight-story Hurth Hotel is on the right, across from Cook's Drug Store and Lewis Furniture Company. The blurred object at lower right is a passing Portsmouth streetcar.

The Masonic Temple building, constructed in 1906, was on the northwest corner of Chillicothe and Fourth Streets. A fire nearly leveled the building in December 1925, after which it was purchased by Kobackers Department Store in 1928. Reduced to four floors, the building housed the LaSalle Hotel on the upper floors. Closed in 1971, the building was vacant until acquired by Desco Bank in 1981, which remains there today.

Even older than the City of Portsmouth is the US Mail. Letters have been delivered by horse and buggy, canal boat, steamboat, railroad, automobile, and airplane. In this January 27, 1918, photograph, Portsmouth postal employee J.W. Rickey is on his daily route with the latest means of transport. (Courtesy Bill Glockner collection.)

The offices of the Portsmouth *Times* were located on the northeast corner of Front and Chillicothe Streets from 1900 to 1955. The *Times*, which began publishing in 1852, was one of 24 different newspapers throughout Portsmouth's history. After the paper relocated to its current Sixth Street location in May 1955, the building became headquarters for the local Boy Scouts of America until it moved in 1969. The building was demolished in September 1969. (Courtesy Bill Glockner collection.)

Few images better capture downtown Portsmouth during the 1970s than this view looking south from Sixth and Chillicothe Streets. On the left is the Montgomery Ward store, which opened in March 1957 and remained until March 1972. The building currently houses the Fifth Third Bank. South of that is the historic First National Bank Building, constructed in 1912 and the current location of National City Bank. Closer to the Kentucky hills in the background is the Hurth

Hotel, which still stands as an apartment building. To the right is Martings Department Store, celebrating a holiday with a large American flag on the front. Beyond the bank south of Martings can be seen signs for Smiths Drugs, Wurster Drugs, Kobackers and Bragdons Department Stores, and Atlas Fashions. Note that traffic on Chillicothe Street was one-way for several years.

The Corner Book Store (left) opened in 1899 on the northwest corner of Second and Chillicothe Streets. Owned by Adolph Schapiro, the business sold schoolbooks and stationery supplies, including, no doubt, many of the postcards seen in this book. Following the 1937 flood, Winfield S. Nye operated his popular drugstore from this building. The building was razed in 1967, and the property is the current location of Smith's Drugs. (Courtesy Paul O'Neill collection.)

The Scioto County Children's Home was constructed in 1876 on Grant Street. Located on property that would later become Mound Park, it closed in 1921 when the larger Hillcrest Children's Home opened in Wheelersburg. The building was razed in 1931. Hillcrest operated until 1971, when, due to expanded use of foster homes and child placement agencies, it was no longer needed. It was soon torn down to make way for residential housing.

Winter's Shoes, located at 509 Chillicothe Street, is seen in this photograph of a sidewalk sale around 1900. Owned by Henry Winter, the store was located opposite the old post office and featured items produced from the many Portsmouth shoe factories. In business for several years, it was not able to survive the Great Depression, filing for bankruptcy on July 20, 1931. (Courtesy Paul O'Neill collection.)

Although it is a rare occurrence, the Ohio River at Portsmouth has completely frozen over, including in January 1940, when a severe cold spell struck the region. In this January 28, 1940, postcard, area residents are braving the elements to walk across the river between Ohio and Kentucky. Ice measured nearly one foot thick, and the river was closed for two weeks. (Courtesy Paul O'Neill collection.)

Looking East on Second Street, from corner of Market Square, Portsmouth, Ohio.

Looking east from Second and Market Streets around 1910, this view includes Brunner's Dry Goods and Carpets store on the left. Constructed around 1850 on the site of a former jail, the building was occupied by Swiss immigrant Rudolph Brunner, who opened Portsmouth's first department store in 1853. Selling materials for people to make their own clothing and carpets, the business remained at this location until relocating in the 1920s. During the Civil War, the store's basement was used as a stop on the Underground Railroad, where escaping slaves from the South would be sheltered and cared for. Changing ownership several times in the following years, the structure was purchased by Greek immigrant Andrew Loukes, who opened Candyland and Variety Store in 1939. During World War II, it was not uncommon to see people lined up for blocks to purchase items from Candyland. After Loukes died, his sister Steliane Loukes operated the variety store for many years. Condemned in 1996 and nearly razed, the structure was saved by local citizens with the hopes of full restoration. (Courtesy Bill Glockner collection.)

The Wilhelm Opera House opened in 1878 on the corner of Fourth and Court Streets. It was the first recorded theater stage in the Portsmouth area. Wilhelm, a German immigrant, came to the United States in 1852 at the age of 19 and settled in Chillicothe, working in the wholesale grocery business. Four years later, he moved to Portsmouth and opened his own retail grocery store on Front Street. In 1857, he married Sophia Schwartz of Chillicothe, and together they had nine children. Two decades later, he used $35,000 to construct his dream of retail, residence, and recreation all under one roof. The first floor housed his expanded grocery store, the second floor was set aside for his living quarters and office, and the third floor contained the opera hall, with a seating capacity of 750. In 1908, a large remodeling project converted the second floor to apartments, while the stage that saw hundreds of live performances was removed from the third floor and replaced with a dance floor. (Courtesy Bill Glockner collection.)

HUTCHINS STREET, LOOKING NORTH, PORTSMOUTH, OHIO.

Before the popularity of telephones and other technology in the early 1900s, picture postcards were the primary means of communication between people, whether hundreds of miles away or just a few blocks apart. Many of Portsmouth's early postcards featured buildings or everyday street scenes and were photographed by either the Lorberg or Cook studios. Some of these images were sent to Germany, where color was added and the card reproduced, then returned across the Atlantic Ocean to be sold in local stores. In 1915, World War I blocked the import of any more postcards from Germany, and the studios began using printing companies within the United States. Among such residential scenes are Hutchins Street (above) and Lincoln Street (below). Postcard collecting, known as deltiology, ranks as one of the largest collectible hobbies in the world.

Lincoln Street, looking South, Portsmouth, Ohio.

When the opportunity arose, Portsmouth was always ready to have a parade. One of the most popular in the early 1900s was the annual Children's Parade (above) held on Flag Day. Nearly 4,000 students were dismissed from classes and encouraged to show their patriotism by marching through the city, wearing their best clothes and waving American flags. Led by the High School Cadets, the parade extended more than one mile and featured all of the nearly one dozen schools within Portsmouth. Carrying a banner advertising their names, the schools would compete with one another to have the most participants and to draw the most applause from the thousands of townspeople lining the streets. Other patriotic pageants, such as that held on the Fourth of July (below), saw anything and everything decorated red, white, and blue. (Courtesy Paul O'Neill collection.)

Raven Rock, located west of Portsmouth along the Ohio River, is one of the most majestic natural wonders in southern Ohio. It is not known how the overlook received its name in the 1700s, but every story is interesting. One legend has a Cherokee war chief named Raven jumping to his death from this spot while in a battle with local Shawnee Indians, choosing death over dishonor after becoming weakened by the long battle. Another theory simply points to the shape of the rock, which resembles a bird with a wingspan nearly one-half mile wide. Regardless, it is known that this was a vital Indian lookout spot for decades, approximately 500 feet above the Ohio River. The Shawnee were able to view nearly 14 miles of river, watching for enemy Indian tribes or, later, the white man traveling in flatboats. In modern times, several businesses have used the name, including Raven Rock Airport. The Ohio Department of Natural Resources governs and protects the area today, imposing restrictions on those eager to hike the trail. (Courtesy Paul O'Neill collection.)

Union Mission, at Court and Front Streets, was operated by Carl and Marjorie Edwards, who cared for people's physical and spiritual needs. Carl Edwards was a street minister, preaching to those who may have taken advantage of the many local taverns. Sunday school was taught by teachers from the area churches at 2:00 p.m., so as not to interfere with people's duties at their own churches. The mission also operated a clothing store. If someone was unable to afford the clothing, it would be given to them free of charge. A 1937 newspaper advertisement stated that the mission never closed during the 1937 flood, caring for 115 homeless people during that time. Evidence of its purpose appeared in a report from 1964, which stated that in the first three months, 5,446 meals were served, 1,728 people were given beds overnight, 215 one-time transients were registered, and 1,656 articles of clothing and 69 pairs of shoes were given away. Help was provided to 85 families totaling 396 persons, and 137 religious services were held. (Courtesy Paul O'Neill collection.)

The Smokehouse and Ben Hur Hall, located on the northwest corner of Fifth and Chillicothe Streets, are seen in this 1920 photograph. In 1932, American Savings & Loan opened in a section of the building. A women's clothing store occupied the corner portion, followed by a children's store and Smith's Drug Store. In 1970, American Savings expanded and remodeled the entire building, and remains there today. (Courtesy Paul O'Neill collection.)

In 1863, Spry Drug Store, on the right in this 1922 postcard, was the first to occupy the northwest corner of Second and Markets Streets. It remained there until the business was sold to Brandel's Drugs in 1915. Smith's Drugs acquired the property in 1929. Known as Lantz Drugs from 1935 to 1970, it was later purchased by Lance Sundry Store. A catastrophic fire on May 3, 1978, destroyed the 115-year-old building.

The First National Bank was located on the southeast corner of Gallia and Chillicothe Streets. A towering eight stories, the building has always been one of the tallest structures in Portsmouth. Constructed in halves 12 years apart, the first section (right) was completed in 1912. In 1924, an identical addition (below) was completed on its south side, on property once occupied by the Lyric Theater. The bank changed its name to the National Bank of Portsmouth in 1933, and retained that name before changing to BancOhio in 1979. Ownership later changed again to National City Bank. (Courtesy Bill Glockner collection.)

The Security Savings Bank, constructed in 1917, was located at 825 Gallia Street. The name was changed to Security Central National Bank in 1930 following a merger. The building received heavy damage from the 1937 flood, as waters nearly reached the second-floor windows. A plaque marking the floodwaters' height remains on the exterior west wall of the building. In 1976, the bank relocated to the former Montgomery Ward building on Chillicothe Street, and donated its former building for use as a museum. For the next several months, multiple fundraisers were held to assist in opening the new museum, which would be the first of its kind in Portsmouth. In a May 1978 campaign, every school district in Scioto County participated in a spare-change drive. Over 20,000 students and teachers were actively involved in the project. The donations were successful, and the Southern Ohio Museum and Cultural Center opened in September 1979. (Courtesy Bill Glockner collection.)

F. C. Daehler Co. Funeral Home, Portsmouth, Ohio

The Daehler family and its mortuaries have been present in the Portsmouth area for well over a century. Frederick Carl Daehler was 18 years old when he left his native Germany in 1854 and came to Portsmouth. He started a business in the Kricker Building, then, in 1876, moved to Front Street, where he opened a mortuary and furniture store. Due to the firm's increasing popularity, he had to relocate to larger facilities at Fourth and Chillicothe Streets, and, in 1884, to a building on Market Street. The business moved yet again in 1900, into a five-story building on West Second Street known as the Daehler Furniture and Mortuary Building. The family-operated business remained at this location until 1924, when it was decided to erect a new structure (shown here), at 915 Ninth Street. When Daehler passed away in 1926, the surviving family members decided to close the furniture business and focus on the funeral parlor. The F.C. Daehler Mortuary Company remains at this location today.

The first floodwall constructed to protect Portsmouth from the Ohio River was completed in 1909, and stretched from the Scioto River eastward to Chillicothe Street. By 1930, the wall was extended to the East End at a total cost of nearly $600,000. The wall provided residents with a sense of security. Regrettably, events in 1937 illustrated that it was built too short. (Courtesy Paul O'Neill collection.)

Organized in 1894, the Salvation Army of Portsmouth provides incalculable charity and assistance to those affected by various disasters. In 1907, it was located in this building on the southeast corner of Eleventh and Chillicothe Streets. A successful fundraising campaign in 1955 provided $35,000 to construct a new facility at 1001 Ninth Street. The building was razed in 1957 and replaced with a gas station. (Courtesy Paul O'Neill collection.)

The first gas station in Portsmouth opened in 1914 on the northeast corner of Gallia and Offnere Streets. In April 1926, Richard Mittendorf purchased it and, as seen in this postcard, renamed it, appropriately enough, Pioneer Station. Marvin Jones acquired the property in 1932 and, seven years later, changed it to a Lincoln Mercury automobile dealership. The property was sold in 1959 and served as Newman's Auto Parts until it was later purchased by Cornerstone Church. (Courtesy Bill Glockner collection.)

Only the structure on the lower right, currently a restaurant, still stands from this 1910 view of Chillicothe and Gallia Streets. The adjacent property became the National Bank Building in 1912. The post office, razed in 1956, was replaced by Montgomery Ward. The three-story Kricker Building was destroyed by fire in 1938, and the church in the background, razed in 1927, is the site of the Masonic temple.

Taking part in the annual Decoration Day Parade around 1910, ladies and children walk up an unpaved Offnere Street Hill to Greenlawn Cemetery. Once there, they performed a ceremony at the Soldier's Circle honoring those hundreds who died in service to the country. The Portsmouth observance, now known nationwide as Memorial Day, was organized by Amanda Pursell on May 30, 1862, during the Civil War. Considered by some accounts as the first of its kind in the United States, the observance included Pursell leading the audience to the cemetery, carrying a Bible in one hand and flowers in the other to place on the soldier's graves. Purcell also organized groups of citizens to care for ill soldiers stationed at both of Portsmouth's Civil War camps, and helped provide financial and emotional support to the families of the soldiers. After the war, she was instrumental in raising funds for the Civil War monument that still stands in Tracy Park. (Courtesy Bill Glockner collection.)

The Mary Louise Inn, Portsmouth, Ohio.

The Mary Louise Inn, which opened in 1919 at 843 Gallia Street, was owned and operated by Robert and Mary Louise Lewis. Instantly popular, the establishment proudly catered the first meal to the medical staff and clergy of Mercy Hospital on its opening night in the late 1920s. Other special guests included members of the Cincinnati Reds, who dined there on October 1, 1925, following an exhibition game with the Portsmouth Studebakers at Millbrook Park. The restaurant, later relocated to 737 Fifth Street, became very popular for its desserts and pies. The eatery closed in the 1940s, but was restructured into the Lewis Pie Company. A bakery was constructed on the rear portion of the Lewis residence, at 1417 Fourth Street, and a store was acquired at 419 Chillicothe Street to sell the baked goods. Pies were assembled all night at the bakery and prepared in a large oven capable of baking 60 pies at once. The bakery's cherry, Dutch apple, and pumpkin pies were so popular that restaurants in Columbus and Huntington would purchase them for resale. (Courtesy Bill Glockner collection.)

THE OLD LADIES HOME, PORTSMOUTH, OHIO

The bluntly named Old Ladies Home was located on the southwest corner of Front and Chillicothe Streets, across from the Portsmouth Times Building. Organized in 1883 by Cornelia Hutchinson, it was designed to provide safe housing for women aged 65 and older who had no homes or family. Originally located at Gallia and Bond Streets, the first residence lasted only a year before being damaged by the 1884 flood. A second house was located on Fourth Street and remained in use for over 20 years. In August 1889, John Peebles donated property on Front Street to be used exclusively for a more modern home. Following a lengthy fundraising campaign led by businessmen and citizens, the newly constructed home opened on September 21, 1896. This residence, shown here, featured seven bedrooms and spacious living quarters. No expense was spared in providing the finest living conditions possible. Unfortunately, the number of those entitled to live there soon exceeded its capacity, and by 1926, the facility was relocated to a larger house nearby on Second Street. This house then became a private residence. (Courtesy Bill Glockner collection.)

Anderson's Department Store, located at 301 Chillicothe Street, was constructed in 1898. Considered one of the leading retail stores in Portsmouth for many years, it stocked nearly everything, from ladies' dresses to living-room suites. Among the many popular promotions was the yearly Christmastime visit by Santa Claus. Hundreds of children came from the entire area, and the crowds rivaled any other event during the year. To increase its variety even more, the company built two additional floors in 1925, increasing the building's height to six stories. In 1935, the business was acquired by Sears, Roebuck and Company as one of its 400 department stores nationwide. For nearly half a century, Sears operated the business through both prosperous and difficult economic times. In 1984, a corporate decision closed the Sears building, and the business was relocated. Portsmouth attorney Franklin T. Gerlach purchased the building and converted it into apartments, which remain today. The building was listed in the National Register of Historic Places in 2001. (Courtesy Paul O'Neill collection.)

Discover Thousands of Local History Books Featuring Millions of Vintage Images

Arcadia Publishing, the leading local history publisher in the United States, is committed to making history accessible and meaningful through publishing books that celebrate and preserve the heritage of America's people and places.

Find more books like this at
www.arcadiapublishing.com

Search for your hometown history, your old stomping grounds, and even your favorite sports team.

Consistent with our mission to preserve history on a local level, this book was printed in South Carolina on American-made paper and manufactured entirely in the United States. Products carrying the accredited Forest Stewardship Council (FSC) label are printed on 100 percent FSC-certified paper.

MADE IN THE USA